WANTED

6
5
LAPD
77TH PRECINCT
NO. - 8 4 1 5 2 4 9

6
5
4
LAPD
77TH PRECINCT
NO. - 8 4 1 5 2 4 9

ED BEREAL

FOR

USING POLITICAL CARTOONS WITH THE DELIBERATE INTENTION OF:

"DISTURBING THE PEACE"

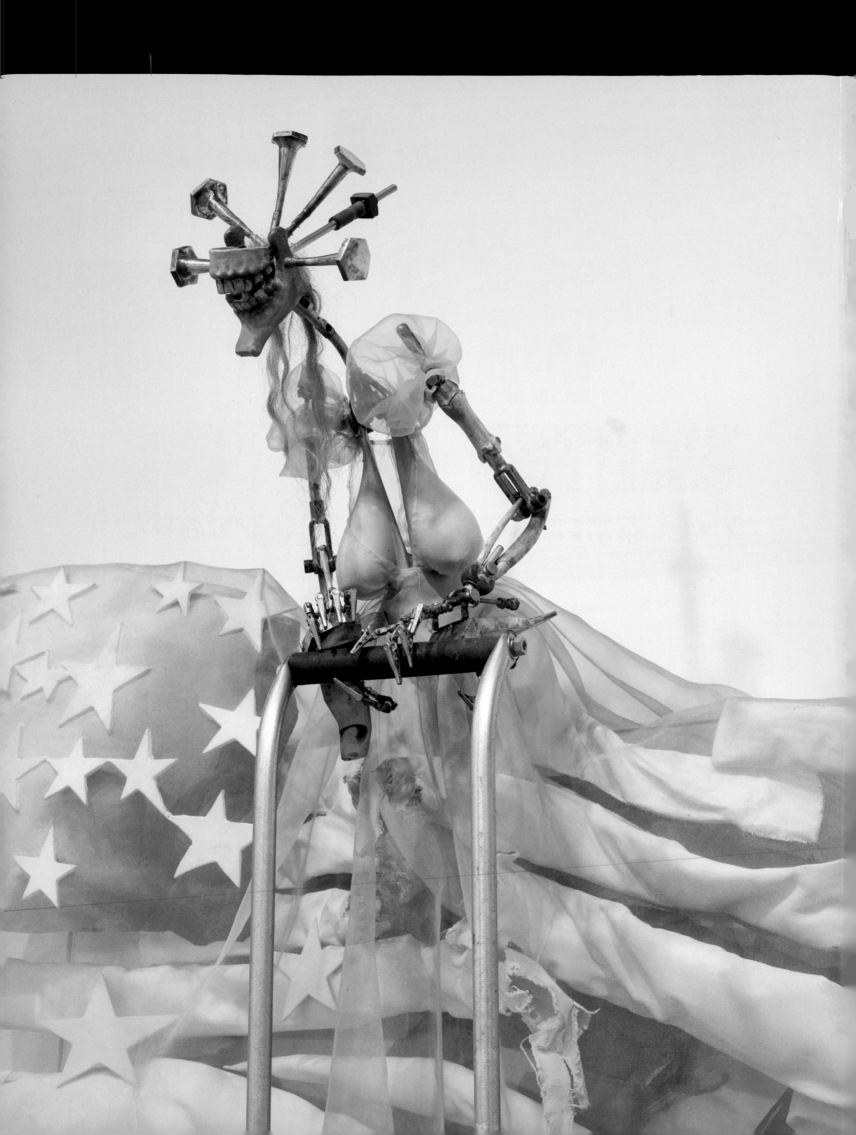

WANTED ED BEREAL
FOR DISTURBING THE PEACE

Amy Chaloupka

Malik Gaines

Vernon Damani Johnson

Matthew Simms

WHATCOM MUSEUM, BELLINGHAM, WASHINGTON

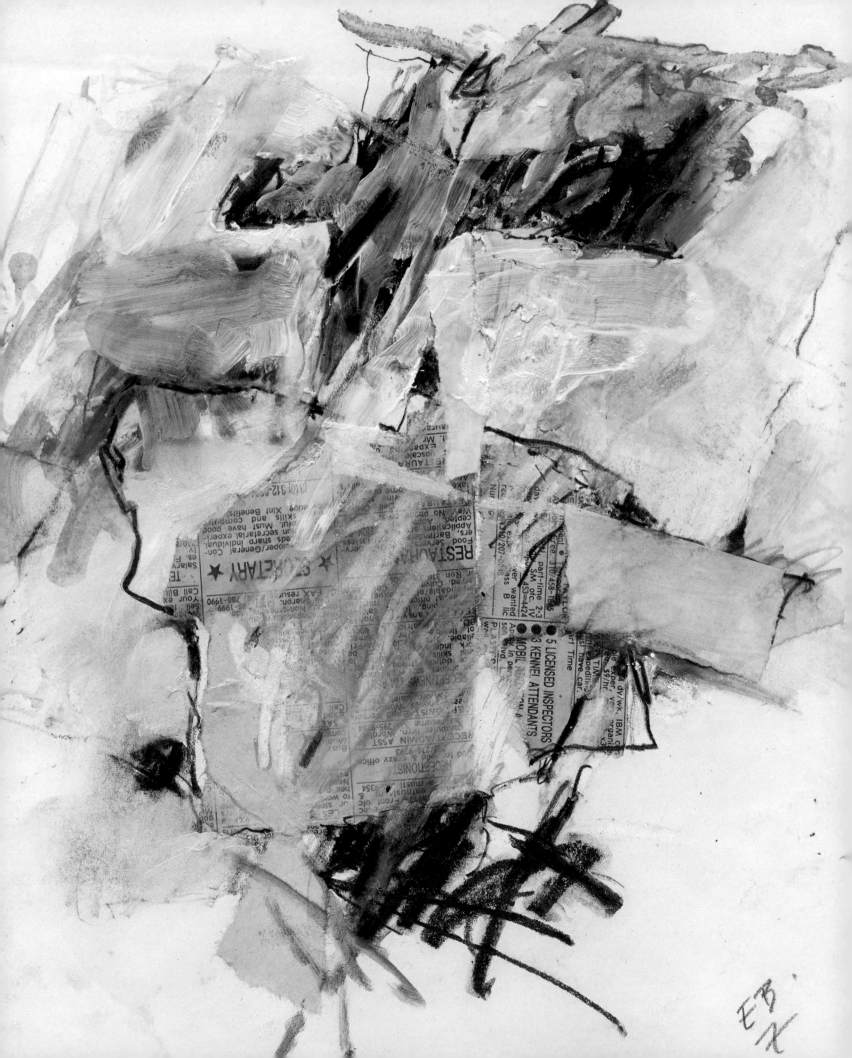

CONTENTS

DIRECTOR'S FOREWORD

The Whatcom Museum is thrilled to present the work of artist Ed Bereal for his first museum retrospective. *Wanted: Ed Bereal for Disturbing the Peace* chronicles the artist's diverse practice through an extensive, six-thousand-square-foot exhibition and a comprehensive publication. *Wanted* brings together Bereal's never before exhibited early drawings dating from the 1950s and 1960s, a newly created forty-foot-long powerhouse installation titled *Five Horsemen of the Apocalypse*, and many of the paintings, sculptures, and performance works he created in the years between. *Wanted* offers the first opportunity to consider the full scope of Bereal's remarkable six-decade career.

Born in Los Angeles, California, in 1937 and profoundly affected by World War II, Bereal made significant contributions to the arts of assemblage and performance in Los Angeles during the early 1960s through the 1980s. A consummate draftsman and object maker, Bereal initially found inspiration in such divergent sources as Norman Rockwell's illustrations and the tableaux of Ed Kienholz. His "political cartoons" are unique portraits of America filtered through the lens of an artist who lived through the 1965 Watts riots, founded the noted Black street theater Bodacious Buggerilla, and traveled to hot spots around the world as a film journalist.

In 1993, Bereal moved to Bellingham, Washington, to join the art faculty at Western Washington University until his retirement in 2007. On his farm in Whatcom County, the artist began processing his life's experiences through an explosion of provocative imagery and narrative, sparking conversations about identity and racial inequity, violence and war, and political and corporate power. These core issues continue to resonate today as the nation moves to find ways to understand its history and define its future.

Only recently has Bereal's work gained wider recognition at such institutions as the Getty Museum, Los Angeles; the Centre Pompidou, Paris; the Moderna Museet, Stockholm; and Cuba's Havana Biennial. Amazingly though, the 82-year-old artist has never had an expansive solo museum exhibition, and the Whatcom Museum is proud to lead the charge.

We are grateful for the thoughtful writing contributions of the four esteemed authors. Amy Chaloupka, Whatcom Museum curator of art; Malik Gaines, professor at New York University's Tisch School of the Arts; Vernon Damani Johnson, professor of political science at Western Washington University; and Matthew Simms, art historian and professor at California State University, Long Beach, have all brought new insights to the varying aspects of Bereal's work.

An exhibition of this breadth is not possible without the generosity and efforts of many. We are especially grateful to the donors, lenders, and supporters of Ed Bereal and the Museum, who have made this project possible.

I thank the Whatcom Museum Foundation and Board, the Museum Advocates, and the Museum Docents for their leadership and championing of the Museum's programs. Special thanks to Curator of Art Amy Chaloupka for her enthusiastic and skillful organization of the exhibition and catalogue, Phil Kovacevich for his thoughtful catalogue design, and Nancy Tupper for her incisive editing. The organization of a project of this scope is dependent on a tireless and professional team to see it through to completion. This includes Director of Exhibitions Victoria Blackwell for her guidance throughout the process, Preparators David Miller and Paul Brower for their installation expertise, Curator of Collections Rebecca Hutchins for her execution of all of the loans and shipments of the artwork, Archivist/Historian Jeff Jewell and his team for their crucial help in preparing images for reproduction, Marketing and Public Relations Manager Christina Claassen, Membership and Development Manager Althea Harris, Education and Engagement Manager Sarah Hart, Chief Financial Officer Charles Marcks, and the Museum's entire staff. We are also grateful for the continued support of the City of Bellingham and Mayor Kelli Linville.

Finally, our deepest appreciation to Ed Bereal for his generosity, energy, and unceasing creative pursuit, which inspires us all.

—**Patricia Leach,** Executive Director

Untitled (Ed Bereal in
his studio, Bellingham,
Washington)
2019
Digital Image
Courtesy of the artist
Photo: Courtesy of
David Scherrer

ACKNOWLEDGMENTS

The exhibition, publication, and related programming for *Wanted: Ed Bereal for Disturbing the Peace* was made possible by the commitment of many individuals and organizations. Both the artist and I extend our sincere gratitude to all of the donors for their generous support, and especially to RiverStyx Foundation, Larry Bell, and Michael and Barbara Ryan.

We wish to acknowledge the museums, galleries, and private collectors who generously parted with their works for the length of the exhibition: Allan and Luwana Bereal, Ed Bereal, Warren and Billie Blakely, The Buck Collection at the UCI Institute and Museum for California Art, Dana Fillmore, Karen Fillmore, Ken Hanna, Leslie Jacobson and Cary Kaufman, Casey Kaufman, Nancy Kienholz, Gordon and Robin Plume, Linda Richman and the Estate of Ron Miyashiro, Chuck and Dee Robinson, Kay Sardo, Smithsonian American Art Museum, Jane and Robert Sylvester, and Tilton Gallery.

Contributing writers Malik Gaines, Vernon Damani Johnson, and Matthew Simms, have our deep appreciation for their enthusiasm and insights into Bereal's work. Special thanks to Phil Kovacevich for his distinctive catalogue design, to University of Washington Press for sharing Bereal's work with new audiences through its distribution, to Nancy Tupper for her sensitive and meticulous editing, and to David Scherrer and Steve Johnson for their important documentation of the project through photography and videography.

We also extend a special thanks to Lee Alexander, Susan Bennerstrom, Piet Bereal, Mark Bergsma, Carol Bourns, Gene Broadgate, David Doll, Cara Fillmore, Tendai Jordan, Olivia Knowles, Michael Krapes, Barbara Matilsky, Amelia Pollock, Colton Redtfeldt, Astrid Schöpfer, and Ron Switzer for their contributions and energies toward the project.

In areas of research and gaining a more thorough understanding of the artist and his work, I wish to thank Karen Lemmey, Chanelle Mandell, Jerry McMillan, Dawn Minegar, Marvin Silver, Matthew Simms, Leslie Umberger, and especially Barbara Sternberger and Ed Bereal, for lending expertise and assistance along the way.

Deep gratitude goes to all of my colleagues at the Whatcom Museum, including the Advocates, Docents, and Foundation Board. Their enthusiastic participation has helped see this project to fruition. I thank Whatcom Museum Executive Director Patricia Leach for her steadfast support of the artist and her unwavering commitment to this ambitious project. Special thanks to Victoria Blackwell, Paul Brower, Christina Claassen, Christy Ham, Althea Harris, Sarah Hart, Rebecca Hutchins, Jeff Jewell, Charles Marcks, David Miller, Lisa Pollman, and Drew Whatley.

I wish to thank Moonwater and her team at the Whatcom Dispute Resolution Center, and the Whatcom Museum Docents and front-line staff for their willingness to collaborate on training in empathic communication related to the challenging themes presented in the exhibition. They have done so in a sensitive and considerate manner while honoring the artist's intent to engage the public in thought-provoking conversation. This training was made possible through funding from the Whatcom Community Foundation's Project Neighborly Grant.

Last, I want to thank Ken, Pearl, and Jasper Hanna for their support and encouragement throughout the planning and execution of the exhibition and catalogue.

—**Amy Chaloupka**, Curator of Art

Generous funding for *Wanted* has been provided by the following donors:
Larry Bell
City of Bellingham
RiverStyx Foundation
Michael and Barbara Ryan
Whatcom Museum Foundation

With additional support from the following:
Sharron Antholt
Antonella Antonini and Alan Stein
Patricia Burman
Heritage Bank
Galie Jean-Louis and Vincent Matteucci
Janet & Walter Miller Fund for Philanthropic Giving
Ann Morris
Peoples Bank
Charles and Phyllis Self
Mary Summerfield and Mike O'Neal
Jane Talbot and Kevin Williamson
Nancy Thomson and Bob Goldman
Whatcom Community Foundation
Whatcom Museum Advocates

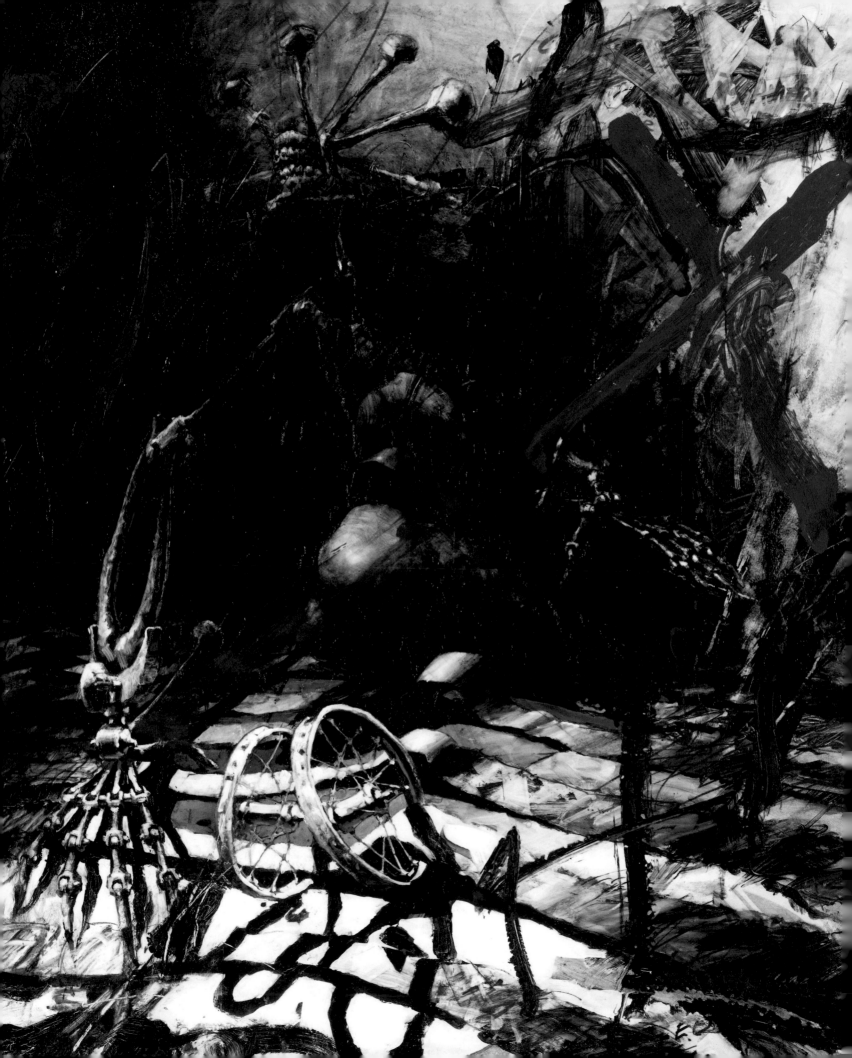

INTRODUCTION

Tireless creative inquiry defines Ed Bereal. He fulfills curiosity by making large and sometimes risky moves. When he found the making of commercially successful art no longer viable for expressing his views, he shifted gears completely and formed a theater group that would take his art-making to the streets. When he wanted to better understand the optical potential of paint, he funded and built a holography lab. His explorations in documentary film have taken him inside Irish Republican Army prisons, to South American rainforests, and on scientific missions in Siberia. He investigates the larger questions in his life through myriad and sometimes disparate, but always passionate, forms of expression. This is what I have admired about Bereal since I was a student in his painting classes at Western Washington University twenty years ago. I always understood that making art—or rather, thinking and producing creatively—was conceivable and valid through a variety of paths. He modeled an artistic spirit for his students, not some narrowed concept of "being an artist."

As a professor, instead of praising skill or perfection, Bereal championed risk, urging students to similarly step outside of their places of comfort. I recall a small but memorable gesture of Bereal bringing a horse from his farm to the university, for students to sketch. The point of this exercise was as much to teach the essentials of life drawing as it was to introduce performance into the act of drawing, and to jar other students out of their typical routine as they confronted this strange scenario while walking across campus. As Bereal would say, "Let's inject a little chaos. Be awake, be aware."

Not only as a former student who learned from him decades ago but now as curator of his retrospective, I am grateful for my own awakening and furthered awareness of Ed Bereal's multi-dimensional practice. My eyes have been opened to the artist's personal journeys and ideological evolutions, and I am thankful to him for generously opening up his studio and sharing personal recollections with me throughout this process. Along with my exploration of the varied paths Bereal has chosen in his six-decade career, this publication highlights three pivotal aspects of his creative thinking, in essays by distinguished scholars Malik Gaines, Vernon Damani Johnson, and Matthew Simms.

Simms and I had the pleasure of visiting with Bereal at his farm and studio over the course of several days, to view his extensive archive of journals, preparatory sketches, and the incredible, expressive loose drawings that date back to the 1950s and '60s. Tucked away in storage for years, most of this work has never been exhibited, much less reconsidered by the artist himself. Simms's writing focuses on this stunning, early burst of creative output. He deftly connects the train of thought in these drawings with the symbolism of the assemblage works for which Bereal is more widely recognized.

Miss America
1993
Oil on paper
24 × 20½ in.
Courtesy of the artist
Photo: Courtesy of Harmony
Murphy Gallery, Los Angeles

Untitled (Ed Bereal seated
with students, University of
California, Irvine)
c. 1970
Silver gelatin print
5 × 7 in.
Courtesy of the artist

Malik Gaines considers the shift of Bereal's work to performance practices in response to the Watts Rebellion. He details the importance of the radical street theater movement of the 1960s and '70s that Bereal championed through his troupe Bodacious Buggerrilla. Gaines had the opportunity to bring Bereal and Bodacious back together for a reunion performance in 2012 as part of the Getty's Pacific Standard Time initiative, which he also discusses.

Vernon Damani Johnson offers the perspective of a close friend and colleague familiar with Bereal's more recent work. Johnson delves into the challenging political tenor that has carried throughout the artist's career. He examines issues of racial inequity, gun violence, corporate greed, and power structures that have stacked the deck against marginalized groups with a suppression that has persisted across the decades. These issues came into sharp relief for Bereal during the Watts Rebellion but, sadly, are ever more at the forefront of our national discourse today and, consequently, continue to be a major subject of his work.

Now in his eighth decade, Bereal describes a newfound freedom in his practice. He feels unrestricted in the multilingual approach that allows him to express a range of ideas through pop art, abstraction, painterly realism, appropriated imagery, and assemblage. This freedom is visible in his most ambitious project to date, *The Five Horsemen of the Apocalypse.* Exhibited for the first time at the Whatcom Museum for this exhibition, the sprawling forty-foot-long assemblage work is a visual manifestation of his uncompromising and unapologetic political and social vision of contemporary American society. Its form is a giant Exxon sign with figures of the four horsemen—Death, Famine, War, and Conquest— inside each

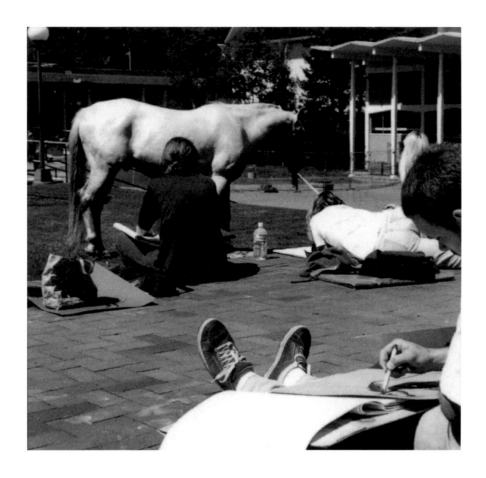

Untitled (life drawing class, Western Washington University)
c. 1998
Silver gelatin print
5 × 5 in.
Courtesy of the artist

letter, and the addition of Predatory Capitalism as his fifth horseman. Their faces are layered with familiar icons—Ronald McDonald and Donald Trump, to name two—and include shifting, optical projections to blur and distort the relationships of all the characters involved. The images are grotesque and frightening, befitting an interpretation of the book of Revelations, but not without a bit of cheeky Bereal humor: he emasculates these boogie men by giving them genitals constructed of gas nozzles and hand grenades. With *Horsemen,* Bereal certainly injects more than a little chaos into his latest work, and it is a sight to see.

I'll sign off as Bereal often does—Keep it surreal and stay tuned.

—**Amy Chaloupka**, Curator of Art

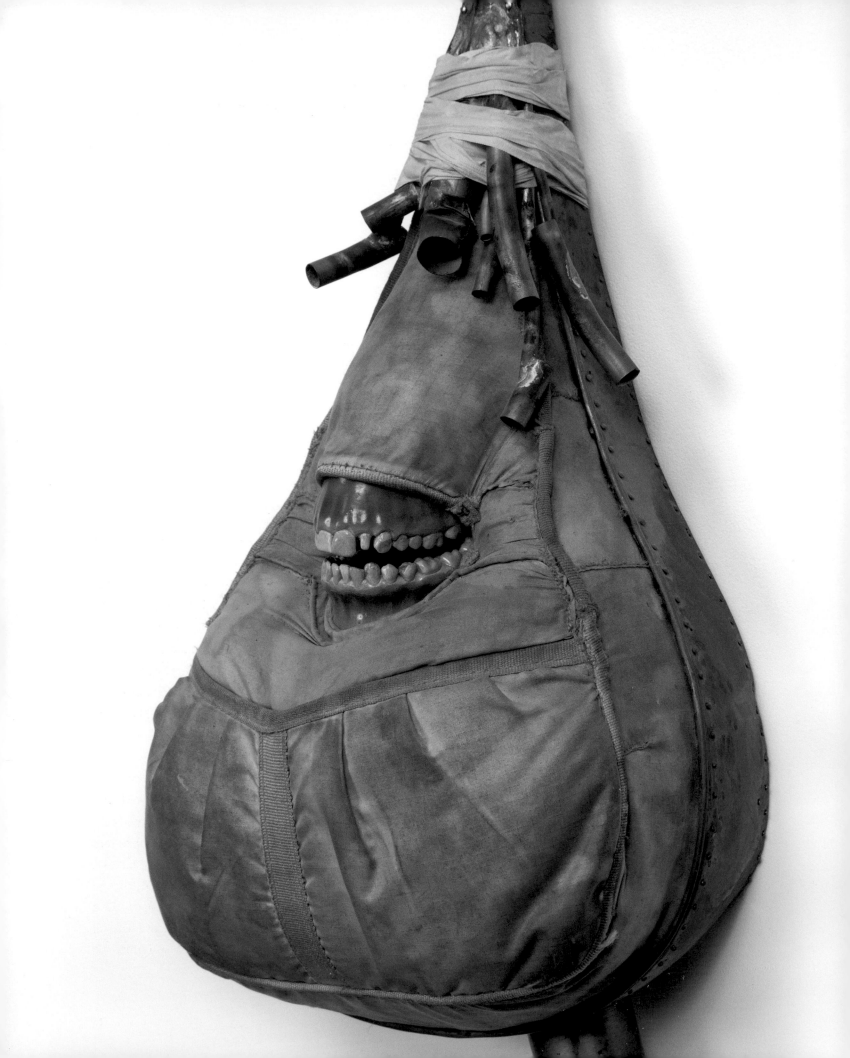

DISTURBING THE PEACE

Amy Chaloupka

I'm not into art for art's sake . . . I think art can instruct, and I think it can destruct—it can be a weapon.[2]

Ed Bereal, "Ed Bereal," *Artforum*, February 12, 2016

AN ARTIST'S BEGINNING

Ed Bereal was born in 1937, on the Fourth of July, in Los Angeles, California. Named after his father, Edmund Sr., Bereal grew up in a musical household that enlivened a childhood otherwise shadowed by segregation, outright racism, and the specter of World War II. His paternal side is of Mexican American, African American, and Native American heritage. The name Bereal is derived from Villarreal and can be traced to homesteaders in Waco, Texas, with a grandfather who headed up a traveling washboard family band (fig. 1). Bereal's mother, Juanita Allen, and father met on a soundstage in Hollywood. She recorded vocal spirituals for film soundtracks while he worked by day as a janitor and toured with the extended family, playing gigs and recording for radio. Bereal grew up in nearby Riverside, California, which was segregated at the time. Swimming pools, bowling alleys, and other public spaces were off limits to Blacks, but the neighborhood he knew was made up mostly of tight-knit African American and Mexican American families. Not until reaching high school did Bereal have much contact with white communities.[1]

Bereal remembers a childhood punctuated by weekend jam sessions and large meals hosted by extended family at both his home in Riverside and at his grandfather's in Los Angeles. Count Basie, Meade Lux Lewis, Billy Eckstine, Dave Brubeck, and other musicians and entertainers were among the group, coming in and out of the fold. In terms of creative output, Bereal always had an inclination toward the visual arts, joking, "I dropped out of my momma and reached over for a pencil."[2] Childhood interests centered on illustration, comic books, and constructing model airplanes. He had little awareness of fine art, though he showed early talent as a draftsman. He cites comic books and Norman Rockwell as huge influences during his youth and has stated later in life that "Rockwell is one of the most political artists out there," citing the illustrator's knack for packaging and selling one particular brand of (white) American idealism through his carefully constructed scenes.[3]

Bereal graduated from high school in 1956, and after two years of community college, he and a cohort of friends aspired to attend Art Center School in Los Angeles, which was known for its illustration program. Application required drawing samples, and Bereal gave some of his more accomplished sketches over to his friends to improve their portfolios. When they were accepted but he was not, Bereal felt mystified. Initially questioning his abilities and cursing his overconfidence, Bereal reflected on the rejection, "I was very naïve." He had only later considered that the decision was based on racial bias rather than talent: his friends who gained admission to the program were white.[4]

This rejection was a turning point that did not leave Bereal disappointed for long. He turned instead to Chouinard Art Institute, where he was accepted into the advertising design program. Artist and friend Ed Ruscha had an experience similar to Bereal's. He recalls, "To me, back then, Chouinard was a second choice . . . but I'm really glad I ended up there because it was much freer and more bohemian than [its rivals]."[5] Initially supported by Walt Disney, Chouinard gained a reputation for preparing students to work in Disney's animation studio. Drawing was the primary emphasis across both the design and the fine art departments. Looking at his extensive archive of sketchbook drawings from his school years—and it is interesting to note that a student at Chouinard would easily fill up one or two sketchbooks in a week's worth of drawing classes—Bereal's skills as a draftsman and his explorations of both abstraction and portraiture are strikingly mature and confidently handled early on (figs. 2 and 3).[6]

Bereal learned to lay out the composition of a drawing along with typography in a graphic, illustrative style in service to the selling of a concept or product. Even in these early design assignments there is evidence of expressive line, dramatic use of light and shadow, and lyrical painterly strokes of color, as

Fig. 1
Photographer Unknown
Untitled (family archive image)
c. 1930s
Silver gelatin print
7 × 9 in.
Courtesy of the artist
Featured in the image are
Bereal's father and mother
(third and fourth from right,
respectively), and grandfather
(third from left, holding banjo)

Fig. 2 (opposite page)
Untitled (self-portrait)
c. 1958–1965
Graphite on paper
11 × 8½ in.
Courtesy of the artist

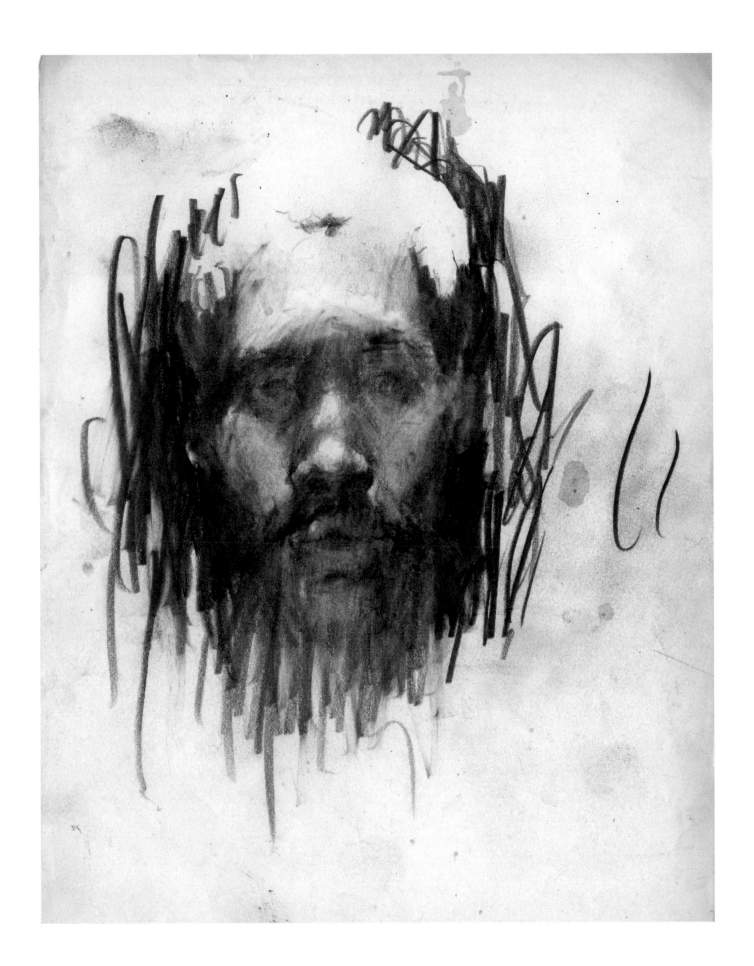

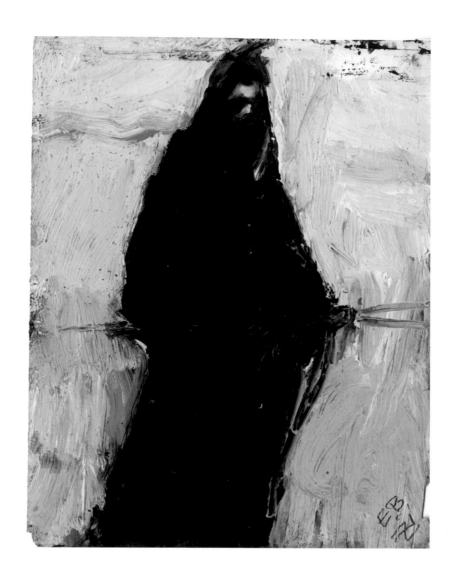

Fig. 3
Untitled
c. 1958–1965
Graphite and paint on paper
11 × 8½ in.
Courtesy of the artist

Fig. 4 (opposite page, top)
Untitled
c. 1958
Paint on board
14 × 16 in.
Courtesy of the artist

Fig. 5 (opposite page, bottom)
Untitled
c. 1958
Paint on board
16½ × 22¼ in.
Courtesy of the artist

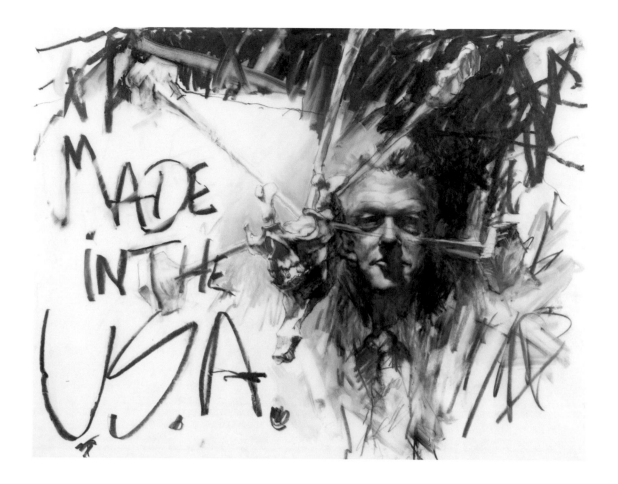

Fig. 6
*Wild Bill and Miss A.
(Made in the U.S.A.)*
2001
Graphite on paper
18½ × 23½ in.
Courtesy of the artist
Photo: Courtesy of Harmony
Murphy Gallery, Los Angeles

well as dynamic attention to negative space (figs. 4 and 5). They veer comfortably into the realm of fine art and lay the foundation for Bereal's skillful blend of text and image composition in the political cartoon paintings to come decades later (fig. 6).

Bereal's time at Chouinard spanned from 1958 to 1962. The school, its faculty, and some of its students were bolstered by Los Angeles area commercial art galleries like Ferus, Dwan, and Huysman. These galleries were gaining prominence and, along with the 1962 opening of *Artforum* magazine's San Francisco office, bringing world renowned artists and critics to the region. Bereal met Marcel Duchamp, Philip Guston, Yves Klein, Niki de Saint Phalle, Man Ray, Larry Rivers, Clyfford Still, and many others. At Chouinard Bereal worked with influential faculty, including Robert Irwin, Richards Ruben, John Altoon, and Emerson Woelffer. Bereal and other students were particularly drawn to Irwin and recall, with clarity, the moment of discovering Irwin's painting class and being introduced to a radical new way of thinking about art. Nobuyuki Hadeishi was a student at the time. He recollects:

> Robert Irwin was the first Chouinard instructor to depart from the conventional notion of art instruction. He stressed the importance of the individual, how each student must search within rather than build on the past. He pushed students to ask themselves why they were doing art, a question Irwin himself couldn't answer. Irwin had deduced, by looking at previous art, that important artists challenge viewers to look at art and life in a new way. He saw art-making as inquiry.[7]

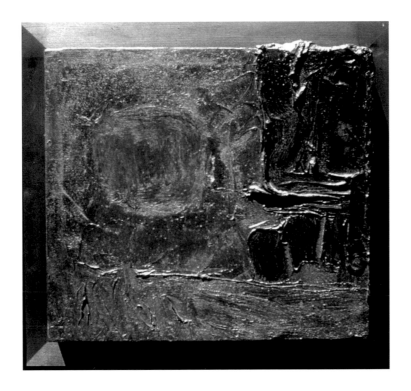

Fig. 7
Giant Steps
1958
Oil on sculpted canvas
20 × 20 × 6 in.
Collection of Allan and
Luwana Bereal

Hadeishi goes on to observe that along with Bereal, students Ron Miyashiro, Larry Bell, Ed Ruscha, and Joe Goode were so moved by Irwin's teachings that they all abandoned their advertising design majors and switched over to fine art. Bereal describes the shift this way: "My illustration classes felt like I was driving a 1949 Ford, [while Irwin's class was] an Indianapolis race car."[8]

It was through Irwin, visiting artists, and a general public awakening to new modes of art that Bereal became keenly aware of the explosive impact that Abstract Expressionism had on challenging painting's status quo. This awareness naturally prompted a change in his own work. He discovered that painting was more than simply creating an image of something: a painting was a thing unto itself. Taking this philosophy to heart, Bereal began to paint paintings that were things. This shift in perspective expanded the possibilities within the medium and, as he put it, gave him "the freedom to allow the paint to be what it can be and do, not hindered by having to look like something."[9] These concepts can be seen in his aptly titled *Giant Steps*, made in 1958 but later named after John Coltrane's revolutionary jazz recordings (fig.7). While *Giant Steps* still took the conventional shape of a canvas, Bereal's inquiry led him to question the "thing-ness" of a painting even further. He began varying the structure of the next piece, carving curves into the stretcher bars to mold a more rounded silhouette. He rationalized that if he was no longer obligated to paint representationally, he was also not beholden to keep his painting contained within the picture plane.

He began painting around the corners, giving the paint more body by adding cornstarch to the pigment and creating inches-thick impasto to build up subtle layers of earth tones in works like *Fokker – D7* and *Summer Mechanic* (figs. 8 and 9). *Summer Mechanic,* so named because Bereal developed it over summer break while working as a car mechanic back home in Riverside, incorporated the objects of his trade into the paint surface—a steel plug, various bolts, rusted nails, and plumbing fixtures. The integration of these found objects into the work was an intuitive and natural progression for Bereal and garnered

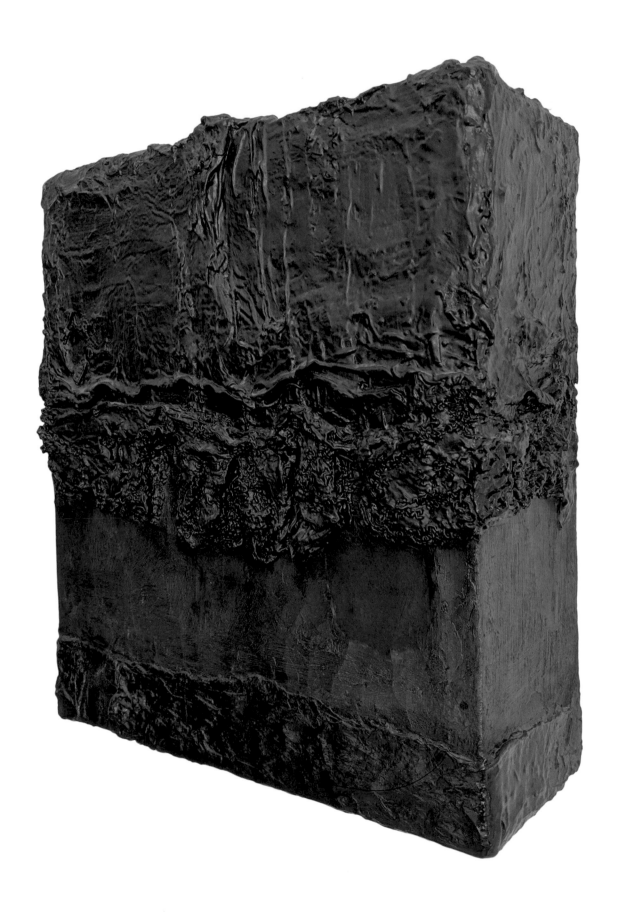

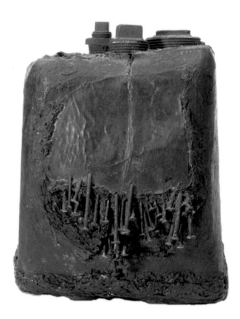

positive response upon returning to Chouinard in the fall. Richards Ruben was so impressed by the piece that he introduced Bereal to collectors, which led to the sale of the work. More significantly, the piece marked a shift in Bereal's (and others') thinking about his work in terms of assemblage and introduced him to a broader art community outside of art school.

DEFYING DEFINITION

Along with Bereal, many artists coming out of Los Angeles in the late 1950s and early 1960s adopted assemblage in their work. The term and practice gained wider attention. Walter Hopps, Cofounder of Ferus Gallery, espoused the concept of assemblage as growing out of Dadaism and Surrealism. As curator of the Pasadena Art Museum, Hopps was responsible for bringing the work of Kurt Schwitters and Marcel Duchamp to the area in 1962 and '63, respectively. His groundbreaking exhibitions fortified the roots of assemblage to European Modernism and forged the link with its Los Angeles area practitioners.[10] Bereal was affiliated with this group of established assemblagists, having lived with Hopps for a time, orbiting within his sphere. He was taught by many Ferus-represented artists. Bereal's work is often discussed in the same conversations as that of Ed Kienholz, Wallace Berman, Joe Goode, George Herms, and others.[11] But Bereal never quite felt comfortable being placed within a white, European lineage or having his assemblage referred to by critics at the time—including John Coplans in *Artforum*—as "fetish objects."[12] Bereal reflects that his explorations felt more aligned with jazz and blues musicians, or makers like Simon Rodia of Watts Towers, whose creative output seemed "transformed into a physical extension of personal being."[13] Bereal states, "There was always, for me, a continuous resonance and dialogue with the art of Muddy Waters, James Brown, Screamin' Jay Hawkins, and assemblage as a cultural phenomenon with intimate ties to my community." He goes on, "Outside of anything in this realm that could remotely be called art, for many of us from deprived communities, assemblage had existed long before it had a name or designation. Due to class, culture, economics, what was later to be called assemblage in polite circles had always been experienced in the real world as a creative response to necessity."[14]

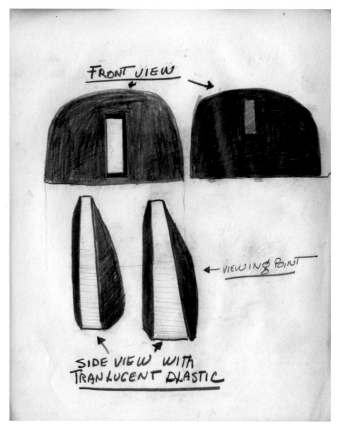

This sensibility and purpose that Bereal describes could place him more in context with the Black Arts Movement, which coalesced in the mid-1960s in Los Angeles after the Watts Rebellion. The group of young black artists included Noah Purifoy, John Outterbridge, Betye Saar, David Hammons, and Melvin Edwards, all of whom were using assemblage in their work. But Bereal was never much affiliated with this group, as he had left this kind of art-making, and the established arts community altogether, in search of other creative modes in response to Watts.

Bereal's interests also shifted in and out of other dominant movements happening in Los Angeles at the time, such as Finish Fetish and the Light and Space perceptual works that were emerging. These affinities, all of which Bereal felt were fair game for his own art-making, made him hard to define. He had interest in car culture, built motorcycles, and employed auto body finishes in works like *American Beauty*. He investigated the use of illusionistic space as early as 1962 (figs. 10 through 12). This exploration was initiated by a profound moment of discovery that Bereal had, quite unexpectedly, while driving in his car one evening. With the backseat full of supplies, the headlights of a truck approaching from behind shone through the overlapping layers of perforated holes in a stack of pegboard, creating a strange light phenomenon that hovered in an eerily disembodied manner behind him. This powerful sensory experience led to an explosion of handwritten notes and planning sketches for the visual hovering effects seen in the work *Immortal Beloved* (figs. 13 through 17).

But Bereal's machines and optics were never quite as clean and polished as the so-called Finish Fetish work he saw in the studios of his contemporaries. (Bereal questioned its implied purism, saying "Everything can't be a car fender."[15]) He was intrigued by the ability to manipulate ways of seeing, and the

Figs. 10 and 11
Untitled (preparatory drawings)
c. 1962–1965
Graphite on paper
11 × 8½ in.
Courtesy of the artist

Fig. 12 (opposite page)
American Beauty
1965
Mixed media
53 × 36 × 14 in.
The Buck Collection at the UCI Institute and Museum for California Art
© 2018 The Regents of The University of California

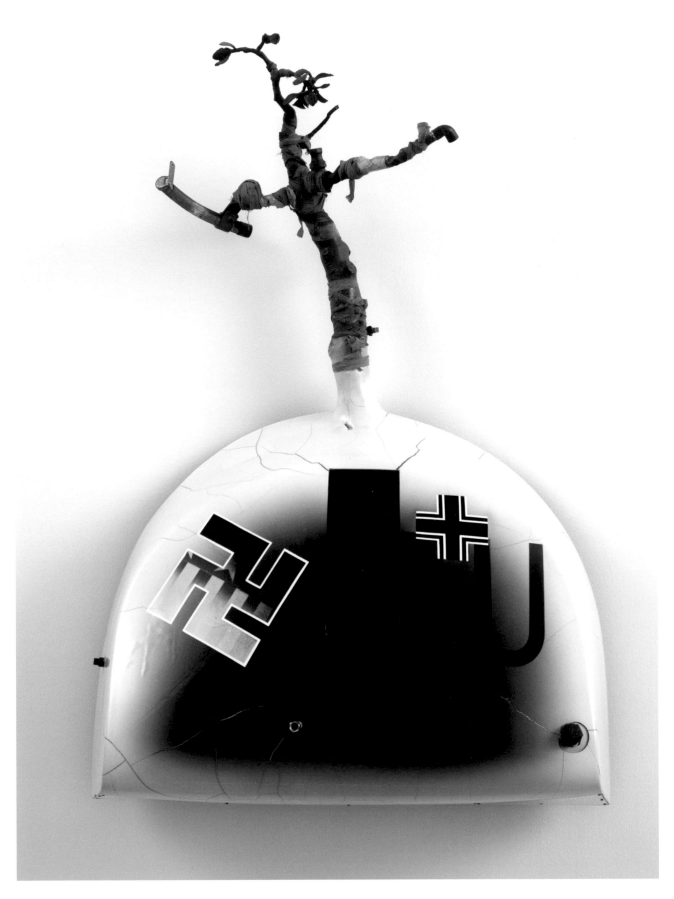

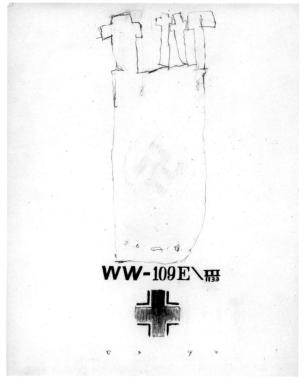

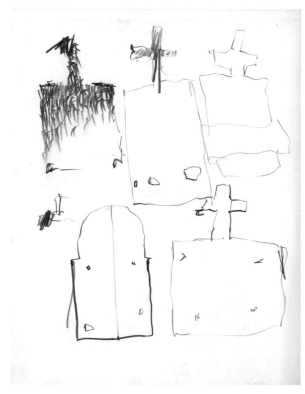

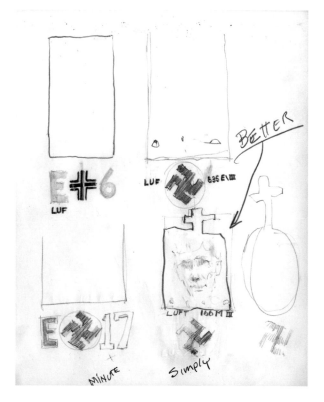

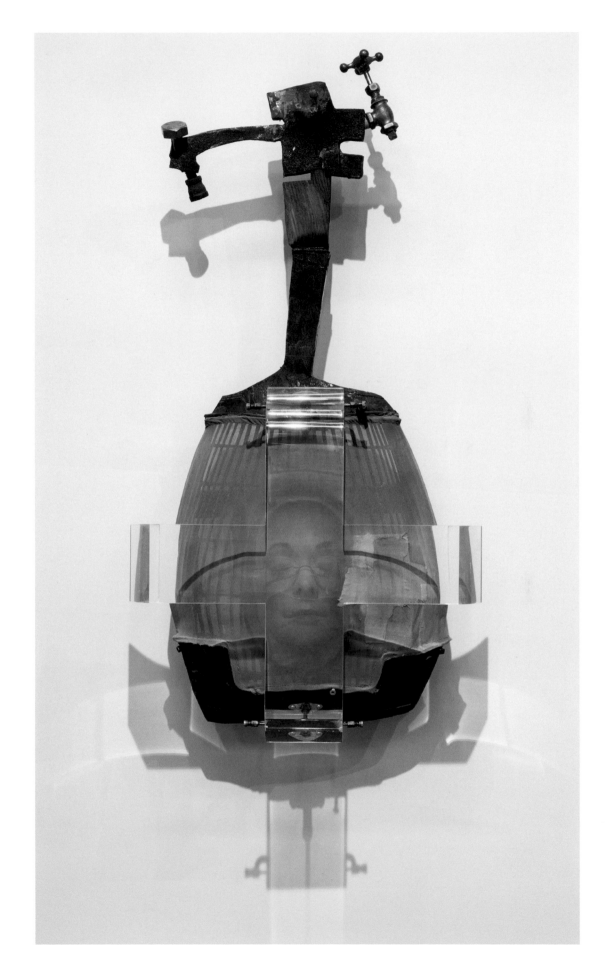

(opposite page, clockwise
from top left)
Fig. 13
Untitled (self-portrait)
c. 1962–1965
Graphite on paper
11 × 8½ in.
Courtesy of the artist

Figs. 14-16
Untitled (preparatory
drawings)
c. 1962–1965
Graphite on paper
11 × 8½ in.
Courtesy of the artist

(right)
Fig. 17
Artist: Immortal Beloved
1962/2015
Mixed media
34½ × 18⅜ ×8 in.
Courtesy of the artist
Photo: Courtesy of Harmony
Murphy Gallery, Los Angeles

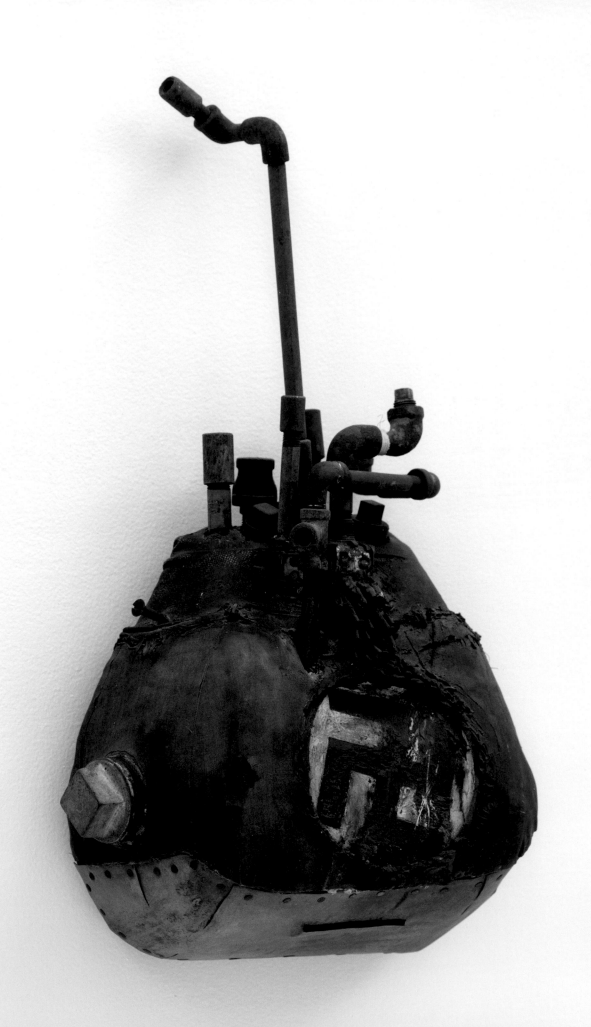

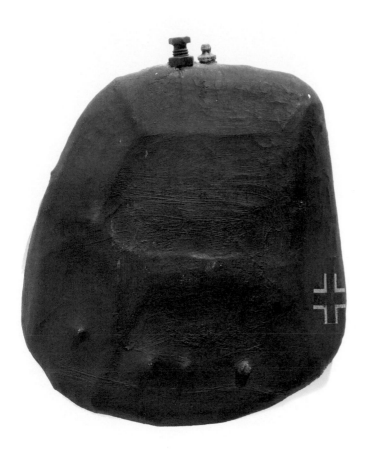
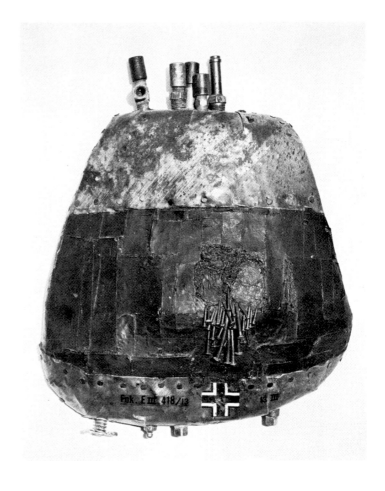

Fig. 18 (opposite page)
Focke-Wulf FW 190
1960
Mixed media
21¼ × 12 × 6 in.
The Buck Collection at the
UCI Institute and Museum for
California Art
© 2018 The Regents of The
University of California

Fig. 19 (above left)
Blohm und Voss P210
1960
Stretched canvas with mixed
media and found objects
8¾ × 8 × 2 in.
Courtesy of Tilton Gallery,
New York

Fig. 20 (above right)
Stuka Ju 87
1962
Stretched canvas with mixed
media and found objects
14 × 11½ × 2 in.
Whereabouts unknown

Photo: Courtesy of the artist

potential for mirrors, screens, and lighting to alter perception and confound the viewer; but his work was rather different from the pristine boxes of Larry Bell or the ethereal discs of Robert Irwin. Bereal relished the construction and mechanics of cars, airplanes, and other complex machines. And under the hood, things are sometimes greasy, leaky, reeking of oil, and rust ridden.

Works like *Junker Ju*, *Focke-Wulf FW 190*, *Blohm und Voss P210*, *Stuka Ju 87*, and *Nautilus* moved completely away from identifiable, framed canvases, reflecting the dirty contraptions that fascinated Bereal (figs. 18 through 20). The work started to present more overt meanings with the inclusion of specific materials and symbols. The titles of the works, their rounded bag-like shapes, the pipes and hardware jutting out of them, and especially the swastika and Balkenkreuz emblazoned on their surfaces, directly referenced Nazi German war machines.

Bereal was particularly entranced as a child by the engineering, innovation, and graphics of German aircraft. As an adult it was the Nazi's takeover of the religious symbols of the swastika and cross as potent iconography that transfixed him, and which he explores again and again across decades of art-making (fig. 21). Bereal was attracted to these incendiary symbols, not in admiration for the ideologies they represented but for their visual power to assault on impact. Bereal reverses the swastika in his own usage, like the Chinese, Native American, and East Indian religious symbol—orienting his graphic counter-clockwise—effectively flipping the context of the charged imagery by physically flipping the form. Yet, the form itself cannot escape a century of laden, implicit content, no matter how Bereal abstracts or distorts it.

With this body of work Bereal participated in the eminent *War Babies* show of 1961. One of the most significant exhibitions ever to take place in Los Angeles, *War Babies* endures mostly through its controversial poster. Besides Bereal, the show included cohorts Larry Bell, Joe Goode, and Ron Miyashiro (fig. 22). According to Henry Hopkins, owner of Huysman Gallery and organizer of the exhibition, Ed Ruscha was supposed to participate as well, but he was in Europe at the time.[16] The poster features the artists sitting at a table draped in the American flag, sharing a meal of stereotypical foods associated with their respective ethnic or religious backgrounds. Bell is eating a bagel; Bereal, a watermelon; Goode, a mackerel; and Miyashiro, rice with chopsticks. The poster was designed collectively and photographed by Jerry McMillan. It was intended to display the diversity of the art and artists coming out of Chouinard. Bereal states that, from a mainstream arts community so lacking in diversity up to this point, *War Babies* was the first exhibition of its kind for Los Angeles.[17] The use of the flag as a tablecloth, however, had a polarizing effect. The Huysman Gallery closed its doors soon afterwards, when its financial backers withdrew their support amid the controversy.

Bereal graduated from Chouinard in 1962. He continued to make work, supported by day jobs as a gallery assistant at Ferus (he remembers unpacking Andy Warhol's *Campbell's Soup Cans* for Warhol's first-ever exhibition), and as a sketch artist for architectural firm Usher-Follis. Bereal says the architect would throw crumpled up pieces of paper onto the table and ask him to turn them into buildings, through sketches (fig. 23).[18] During these years (1962–1965) Bereal spent time in San Francisco where he became associated with ceramic artists Peter Voulkos, Ron Nagle, Michael Frimkess, and Jim Melchert.

Fig. 21
Untitled
1967
Ink on paper
11¾ × 8¾ in.
Courtesy of the artist

Fig. 22 (opposite page)
Jerry McMillan
Poster, *War Babies* Exhibition at Huysman Gallery, Los Angeles
May 29–June 17, 1961
21⅞ × 17 in.
Courtesy of the artist
Photo: Jerry McMillan,
Courtesy of Craig Krull Gallery, Santa Monica, California

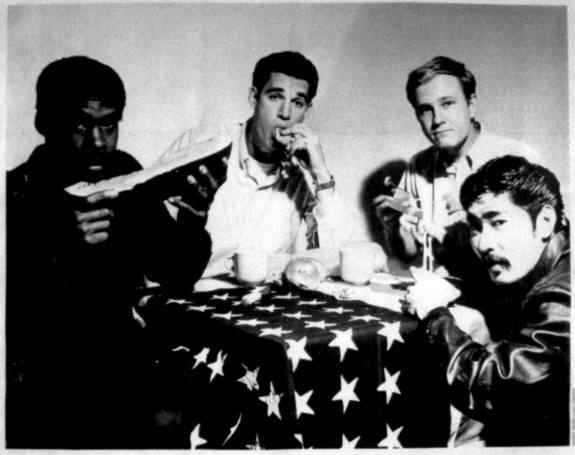

"WAR BABIES"

(1937-1961)

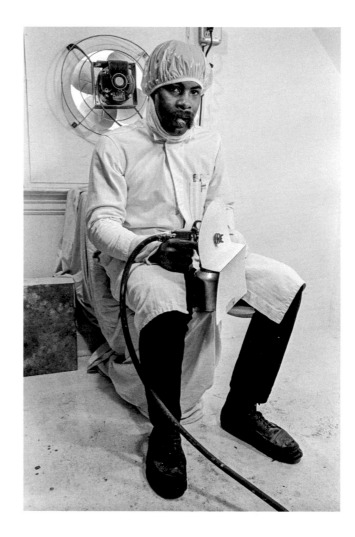

He would also spend time with John Chamberlain in New York, experimenting with auto body paints as a surface material for art. For the next three years, Bereal expanded his skills in clay and explored a variety of surfaces and materials by incorporating lacquers and polymer epoxies into his work (fig. 24). Bereal described this time and the varied experiences as "a great graduate school."[19]

AN AWAKENING

By August 1965, Bereal was living again in Los Angeles, this time at the corner of Western Avenue and Venice Boulevard in Watts. Dwan Gallery paid him a monthly stipend to make artwork. Entrenched in the social sphere of the established art world and fully focused on a day and night regimen of making art, it was not until three days into the Watts Rebellion that Bereal woke up to what was going on in the city that was burning down around him. Opening his studio door on the morning of August 14, Bereal faced the stark reality of a National Guardsman standing on top of a jeep and pointing a .50-caliber machine gun straight at his chest. In that moment Bereal recognized that it did not matter what his pedigree was as an artist; that bullet would still go right through him, with impunity, based on the color of his skin. As he put it, he had been sleepwalking right through the insurrection.[20] "Wow, man, I'm supposed to know about stuff like that. Because of my background and the way I was raised, you never let the street get too far away.

Fig. 23 (above left)
Untitled
c. 1962–1965
Graphite on paper
8½ × 11 in.
Courtesy of the artist

Fig. 24 (above right)
Marvin Silver
Untitled photograph
(Ed Bereal in spray booth)
c. 1965
Silver gelatin print
14 × 11 in.
Photo: Courtesy of Marvin Silver

Fig. 25 (following pages)
America: A Mercy Killing
1966-1974
Mixed media kinetic sculpture
27¼ × 55½ × 45 in.
Smithsonian American Art Museum, Museum purchase

I had gotten sucked up in the art community and I'd lost some of the context of where I'd come from." He continued, "I'm standing there going, I should not have been so removed from certain issues, my culture, and the facts of life, that I could find myself in this situation."[21]

For the next two years, Bereal struggled to make work and return to business as usual after such a paradigm shift. He was disillusioned with his participation in an art world that barely saw the death and devastation of Watts as more than a newspaper headline. Bereal left his gallery in 1967, closed his studio, and went home to Riverside. "I wasn't consciously political, yet I found any involvement in the art world becoming irrelevant, there was a far more exciting dynamic going on in the streets."[22] He started writing, reading, processing. His entire life and lifestyle shifted as he also took on the primary guardianship of two of his young daughters. He attended the Watts Writers Workshop and credits its founder, screenwriter Budd Schulberg, with creating space and opportunity for artists like himself to share their frustrations and put to question the current state of affairs through creative expression. The experience validated a broader feeling of alienation rising within the African American community in Los Angeles, and across the nation, during the Civil Rights era. "I ended up starting to write, because I needed to figure out what was going on. With my roots, with my culture, with who I was in the United States of America."[23]

Bereal's writing led to the development of a screenplay and the construction of an elaborate scale model of a stage set titled *America: A Mercy Killing* (fig. 25). The set was structured to represent the hierarchies of class, race, media, government, and corporate power. Stratified layers were articulated in miniature, with a middle class represented on the central tier by a moving conveyor belt fed by television screens. A junkyard area in the lowest tier represented a "danger zone" of students, artists, and oppressed groups that were outside of mainstream thinking and a "threat to the system." A guillotine with Mickey Mouse as executioner awaited, to castrate and elevate those out of a state of awareness and into the upper levels of greed and mindless consumption. The machinations of these varied groups came together to illustrate the manipulation of public opinion within American society.[24] While the play related to the set piece never came to fruition, the kinetic scale model ushered in a new creative mode of working for Bereal that placed social consciousness at the center of his practice. Housed in the permanent collection of the Smithsonian American Art Museum, *Mercy Killing* mapped the issues that guided Bereal into the most creative seven years of his career, when he founded a street theater troupe called Bodacious Buggerrilla.

This grassroots theater ensemble grew out of a movement in which Bereal found himself at the epicenter. Bodacious Buggerrilla was committed to awakening ideological perspectives through radical performance. After the riots in Watts, universities established black studies programs. Black student unions mobilized. In 1968 Bereal took up teaching positions at both the University of California, Riverside, and the University of California, Irvine, where he engaged black youth in conversations on how to empower themselves. As he had done for himself with *Mercy Killing*, Bereal suggested that students start answering their fundamental questions through theater. This sparked the formation of a group of twelve actors from all walks, including students, a social worker, a former Black Panther, and family members. Bereal organized the group into Bodacious Buggerrilla. Using "guerrilla tactics," they staged their satirical social critique where people in their community gathered—on street corners, in laundromats, on church steps, in prisons, and at local bars (fig. 26). "It was loud, raucous, raw, and irreverent . . . it was angry, compassionate, loving, and hopeful all rolled into one . . . it was surreal, sarcastic, and funky."[25]

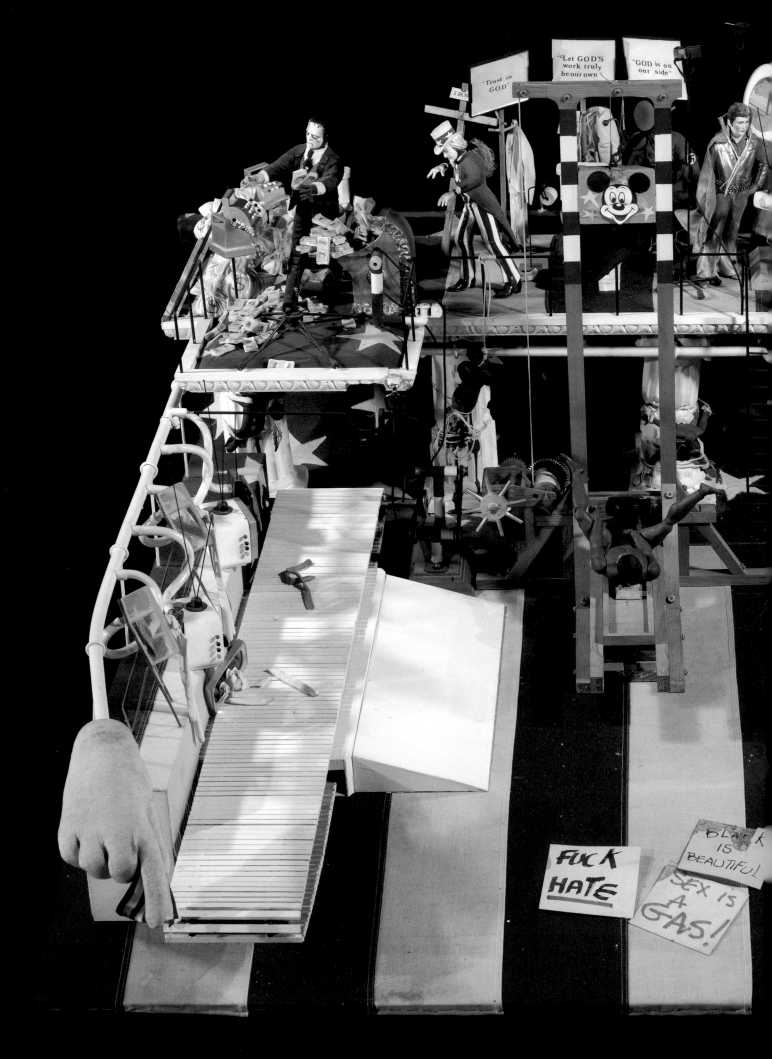

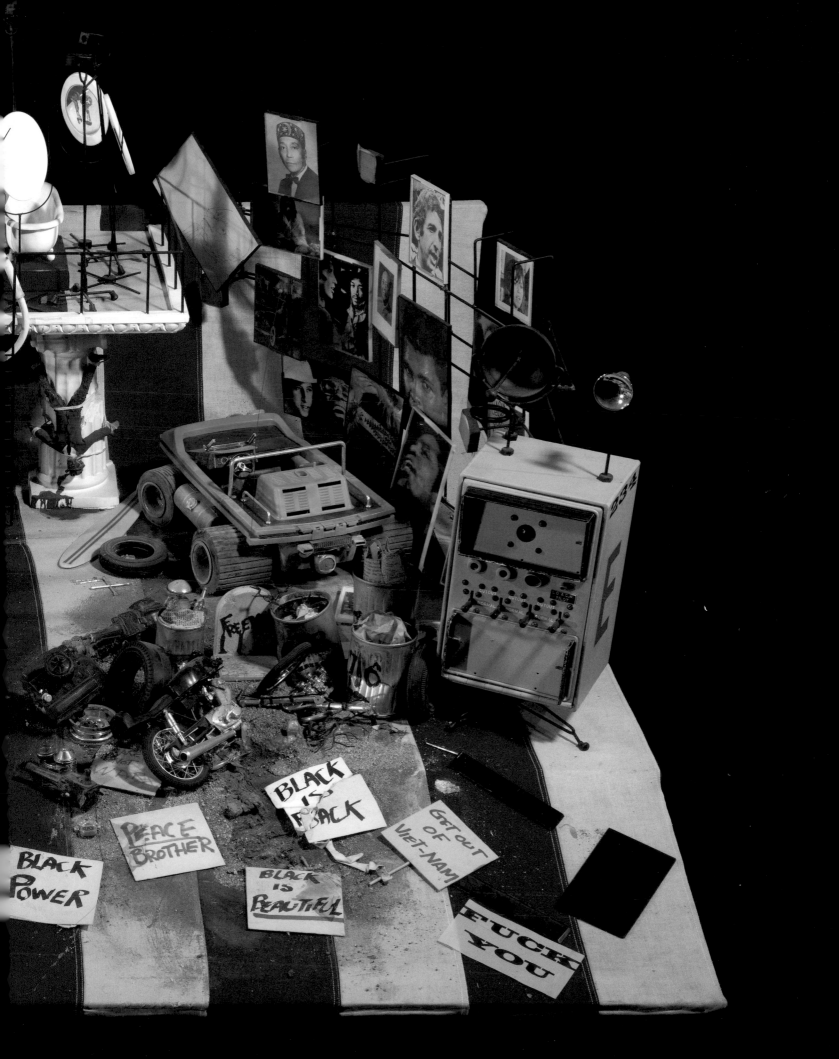

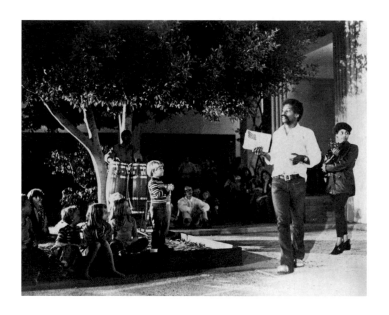 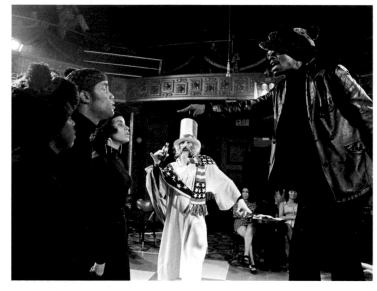

Bodacious Buggerrilla was part of a larger cultural wave of street theater cropping up throughout the country during this time, including the San Francisco Mime Troupe, New York's City Street Theater, and The United Farm Worker's El Teatro Campesino created by playwright Luis Valdez.[26] John Weisman, author of *Guerrilla Theater,* describes the movement as distinct from traditional theater companies in that they saw performance as a social instrument, the goal being not simply to entertain audiences but to motivate, arouse, and organize.[27] Participants, though often untrained, were not only part of the communities they performed in but also authentically connected to the scenarios they enacted. Through their provocative and often farcical brand of performance, they would prompt audiences to ask questions and seek out truths by presenting a variety of power structures for what they were. Bereal has said their intent was to "give [audiences] the knowledge that a hustle is a hustle, and they have a choice. Accept it for what it is, or tell who's ever doin' it to f[***] off, because you're onto his whole game."[28] Bodacious achieved this through skits that satirized the hustle of pimps, examined the many faces of institutional racism, or lampooned capitalism and government to expose their agendas (fig. 27). The process was very improvisational and erased the line between audience and performer. Bereal recalls planting actors in the audience who would express certain opinions in response to stage action. This caused people to ask specific questions: Why *are* my kids talking to me this way? Why *can't* I get a better job? Why *do* they want to shoot us like that? Bereal was master of ceremonies, draped in the American flag and dressed like Uncle Sam. Eventually the group organized in other ways. They started a farm in San Bernardino to teach black youth how to sustain themselves and, through an extensive self-defense program, how to protect themselves. Said Bereal of that time, "We thought that the revolution was about ten minutes away."[29]

Fig. 26 (top left) Untitled (Bodacious Buggerrilla performance at University of California, Riverside)
c. 1968–1975
Archival digital print
11 × 14 in.
Courtesy of the artist

Fig. 27 (top right) Untitled (Bodacious Buggerrilla performance still)
c. 1968–1975
Archival digital print
11 × 14 in.
Courtesy of the artist

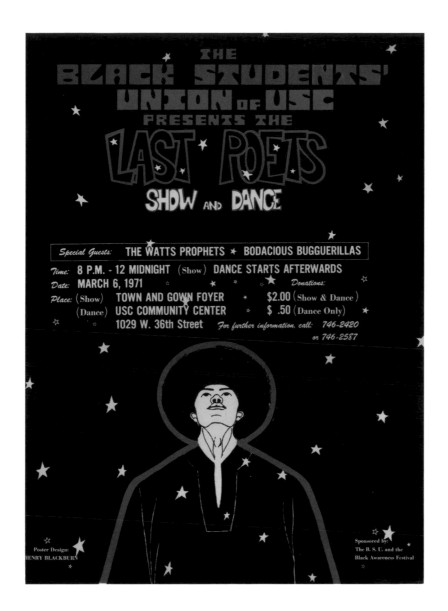

Fig. 28
Untitled (Bodacious
Buggerrilla promotional
poster)
c. 1968–1975
Ink on paper
20 × 18 in.
Courtesy of the artist

Bodacious began expanding to audiences on university campuses and playing larger festivals alongside the likes of spoken-word artists the Watts Prophets, jazz pianist Horace Tapscott, and comedian Richard Pryor (fig. 28). With growing popularity and visibility came greater scrutiny by authorities, questions from the FBI, and outward threats of violence from groups who opposed their message. These pressures prompted Bodacious to move off the streets, eventually morphing into Bodacious TV Works in 1976. The group continued to create subversive skits through more elaborate television productions, including a parody game show pilot called *Pull Your Coat* (see page 73). It aired in 1986 on KPBS, San Diego, for ten days before it was pulled off air for its political overtones. Bodacious was reaching broader audiences, creating public service announcements, collaborating with the Los Angeles Jazz Heritage Foundation, and educating youth in the public schools. But they needed to work within the system by accepting grants from the NEA or taking on side jobs to stay afloat. Under the umbrella of the Bodacious production company, Bereal embarked on a string of video and photojournalism assignments sponsored by Japan Media Group NHK and PontiFex Media Center based out of Georgia, which would take him to political "hot spots" all over the world.

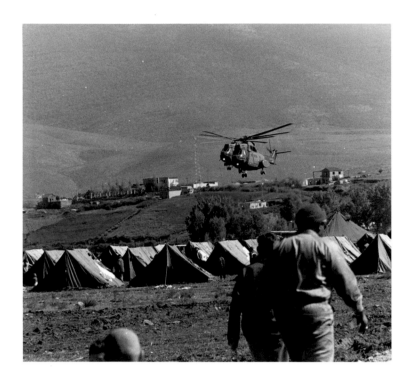

A BROADER WORLD VIEW

Over the next decade Bereal traveled to Siberia, Suriname, Kosovo, Malaysia, North Africa, Ireland, and Cuba. He documented, but also expanded, his own understanding of world religions, culture, science, and geopolitical forces at work. His travels sharpened his eye to the larger role that a capitalist society like the United States plays on the world stage and, in turn, his place within that structure. He brought cameras into an Irish Republican Army prison in Portlaoise, Ireland, teaching prisoners how to film. They, in turn, educated him on their understanding of war, independence, and oppression. With the support of the Center for Islamic Studies in Malaysia, Bereal documented the immigration of Muslims from North Africa, across the Straits of Gibraltar to Spain, and into France. He was asked by the Suriname government to meet and film inhabitants of tribes descended from colonial-era African slaves who had escaped plantations and settled in the remote rainforests. His most difficult and final foreign assignment came in 1999 when he and a small crew visited a refugee camp in Kosovo after the breakup of Yugoslavia (fig. 29). The filming of the realities of genocidal war and the heartbreaking stories told by those encamped there shook Bereal to the core: "I have seen hatred in the world, but nothing compares to Kosovo. The sights, the sounds, and the stories were truly frightening."[30]

Bereal saw firsthand that the United States' decision to either ignore or intervene in world conflicts was directly related to its own economic or political gains. These power plays mirrored his understanding of US treatment of marginalized groups within its own borders, such as black communities like Watts. In tandem with his journalism assignments, Bereal had taught at Irvine for nearly twenty-five years, but by 1993 he was world-weary and ready for a shift on multiple fronts. He moved with his wife, painter Barbara Sternberger, to a farm in Bellingham, Washington, and accepted a position teaching painting at Western Washington University. Once again, he began fleshing out his ideologies through painting and sculpture.

Fig. 29
Salah M. Abdul-Wahid
Untitled (documentary photograph, Kosovo)
1998–1999
C-print
8 × 10 in.
Courtesy of Salah M. Abdul-Wahid and Ed Bereal

Fig. 30 (opposite page)
Ronnie's Purse
1980
Mixed media, found objects
44 × 11½ × 6½ in.
Courtesy of the Estate of Ron Miyashiro
Photo: Courtesy of David Scherrer

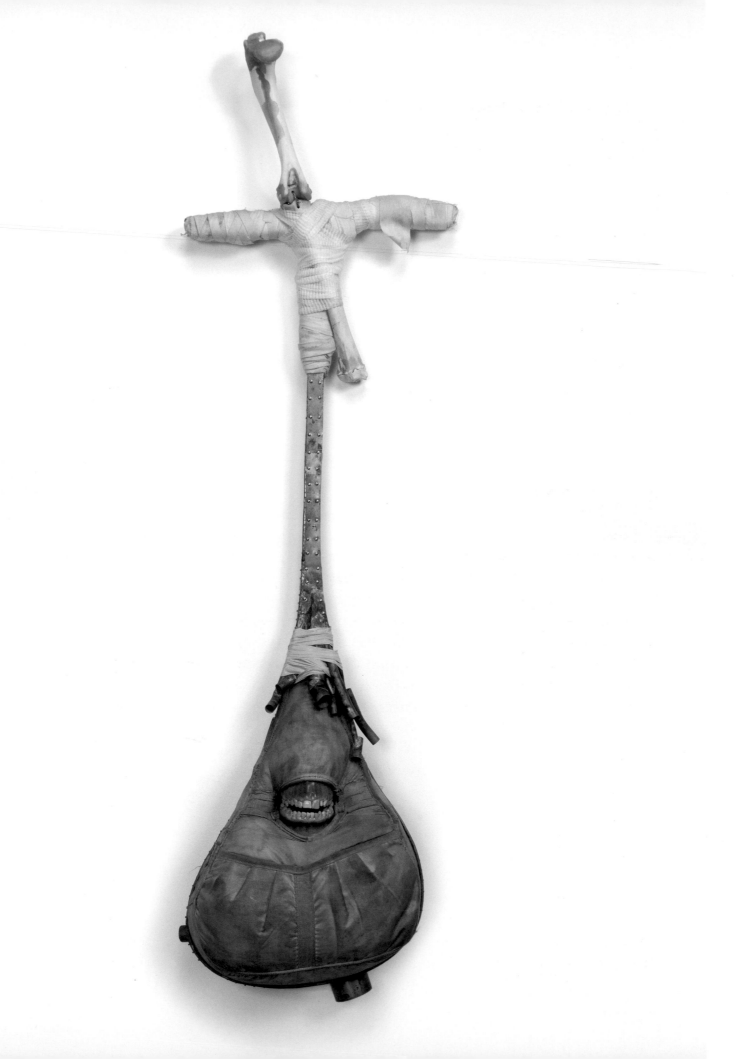

Resuming mark-making and working with his hands after such a long dormancy was not a concern. But conceptually, Bereal's thinking was quite different from when he had turned away from it all in 1965. "What do I want to do? I'm a much more political animal than I was before."[31] He returned to the familiarity of assembling found materials into uncanny forms, creating haunting works like *Ronnie's Purse*. But with its crutch-like mast, the work itself revealed he was relying on themes of the past (fig. 30). He needed a raw, new visual expression that reflected his ideological views while packing a punch. Bereal asked himself, "What *does* America look like from my side of the street?"[32] He recalled Rockwell and Disney's one-dimensional depiction of Main Street USA. The answer emerged as a mangled, garish, twisted vision of Miss America. To Bereal, this character reflected an America that had always privileged one race and class, leaving the marginalized to suffer in its wake of poverty, crime, and repression. She was a gargoyle presiding over her domain with mechanical, groping claws, sneering with a menacing, toothy grin and topped with a Lady Liberty crown that—rather than adorning her head with pride—appeared to pierce her violently with stakes (fig. 31). Like the swastika and Uncle Sam in years prior, Bereal transformed the idea of Miss America into a symbol of his reality, co-opting as well its power of manipulation. With Miss America, he intended to create a visual so frightening that she would spur people to their own awakening, as the National Guardsman and his machine gun had done for him three decades earlier.

THE ARTIST TODAY

At the age of 82, Bereal continues to tap a stream of interests and themes that have persisted across six decades. Works like *Miss America: Manufacturing Consent* and *Homage to LA* are rooted in assemblage, yet Bereal injects a theatrical scale and presentation through lighting and forced perspective. He sets the scene and stages his characters with dramatic intensity (fig. 32). He employs his deft illustration skills overlaid with carefully composed collage in his political cartoons. Paintings *Again* and *Location, Location, Location* present caricatures of political figures puppeteered by Miss America and confront racial stereotypes with provocative text to jolt viewers to attention (see pages 85 and 87).

Perhaps the most unifying force of Bereal's career is the idea of illusion, which can be traced back to that visual epiphany in his car in the early 1960s. The concept has propelled him to explore holography, the craft of magicians, and neuroscience in attempts to harness an optical experience. But more than simply a tool to arrest the viewer with visual tricks, the concept of illusion as a social and political instrument also resonates for Bereal. Through his successful manipulations of paint, image, light, space, and even audience, he conveys this larger political message: that so much of what we see on the surface of our culture is simply illusion and requires persistent poking to get at the truth underneath.

Fig. 31
Untitled (Miss America)
c. 1989–1992
Silver gelatin print
10 × 8 in.
Courtesy of the artist

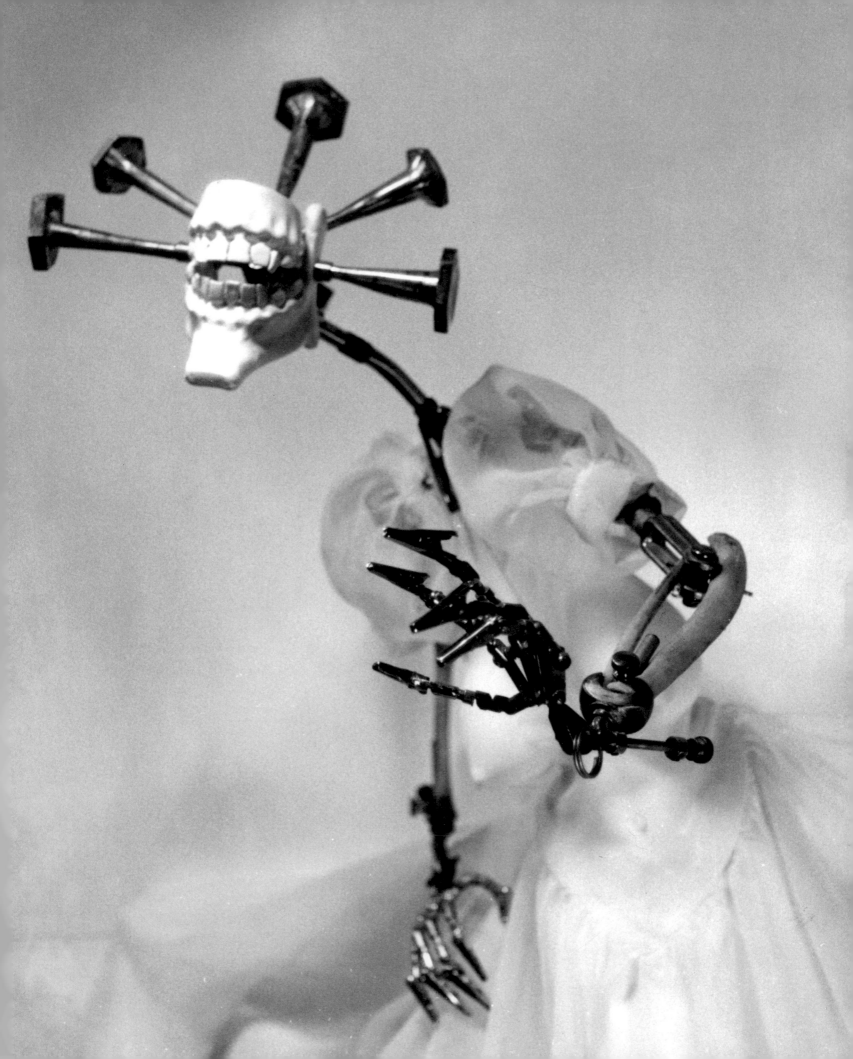

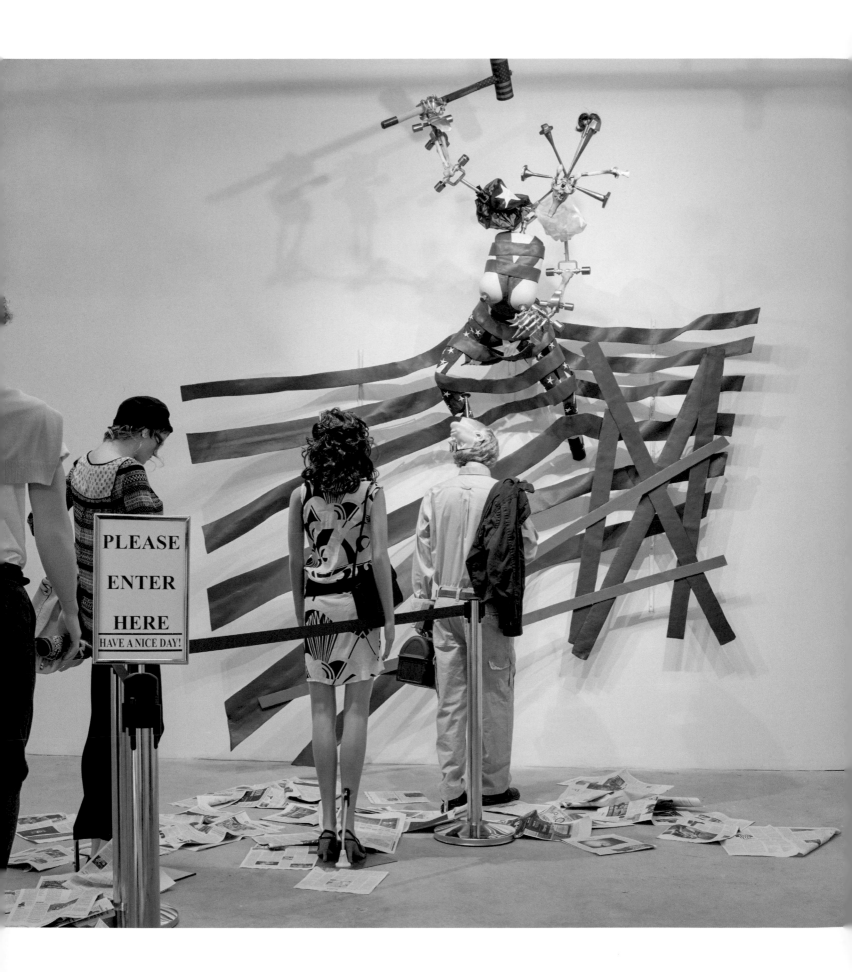

AMY CHALOUPKA

NOTES

1 General information about Bereal's early life comes from artist conversations with the author on March 6, 2019, and in greater depth from "Oral History Interview with Ed Bereal," Feb. 13, 2016, Archives of American Art, Smithsonian Institution, Washington, DC.

2 Ibid.

3 Ed Bereal, in conversation with the author, March 6, 2019.

4 Benjamin Lord, "Ed Bereal Speaks," *Contemporary Art Review Los Angeles*, July 7, 2016. See https://contemporaryartreview.la/ed-bereal-speaks/.

5 John Patterson, "California Dreamers: The Story of Art in the 1950s and '60s," *The Guardian*, October 7, 2009. See https://www.theguardian.com/artanddesign/2009/oct/08/california-1960s-art.

6 For a more detailed history of Chouinard, its faculty and students, and particularly the later years of Bereal's enrollment, see Nobuyuki Hadeishi, "The Last Years (1956–1972)," in *Chouinard: A Living Legacy*, exhibition catalogue (Los Angeles: Chouinard Foundation, 2001), 40–57.

7 Ibid.

8 "Oral History Interview with Ed Bereal," Feb. 13, 2016, Archives of American Art, Smithsonian Institution, Washington, DC.

9 Ibid.

10 For more information on Walter Hopps and his curatorial influence on shaping the definition of assemblage in Los Angeles, see Franklin Sirmans, "Find the Cave, Hold the Torch: Making Art Shows Since Walter Hopps," in *Now Dig This! Art & Black Los Angeles, 1960–1980* (New York: Prestel, 2011), 57–67.

11 These associations were cemented in a series of features on the state of Los Angeles arts in critical reviews in the *Los Angeles Times* and in *Artforum* magazine in the early 1960s, including the August 1963 (vol. 2, no 2), and Summer 1964 (vol.2, no. 12) editions of *Artforum* magazine, with essays on assemblage by John Coplans (1963) and Donald Factor (1964) in which both authors describe Bereal's work as "fetish objects."

12 John Coplans, "Sculpture in California," *Artforum* 2, no. 2 (Aug. 1963): 4.

13 Leslie Umberger, curator of folk and self-taught art at the Smithsonian American Art Museum, uses this phrasing to describe the work of artists Simon Rodia and Howard Finster, in her essay "In Memory of the Blood," part of the exhibition catalogue *Something to Take My Place: The Art of Lonnie Holley* (Charleston: Halsey Institute of Contemporary Art, 2015), 20.

14 Ed Bereal, "I Never Gave Up," unpublished "open letter to Monte Factor," 2005, collection of Ed Bereal.

15 Benjamin Lord, "Ed Bereal Speaks," *Contemporary Art Review Los Angeles*, July 7, 2016. See https://contemporaryartreview.la/ed-bereal-speaks/.

16 Henry Hopkins describes the exhibition in great detail in his oral history: *Oral History Interview with Henry Tyler Hopkins*, Oct. 24, 1980, Dec. 17, 1980, Archives of American Art, Smithsonian Institution, Washington, DC.

17 Franklin Sirmans, "Find the Cave, Hold the Torch: Making Art Shows Since Walter Hopps," in *Now Dig This! Art & Black Los Angeles, 1960–1980* (New York: Prestel, 2011), 60.

18 Ed Bereal, in conversation with the author and Matthew Simms, March 9, 2019.

19 Benjamin Lord, "Ed Bereal Speaks," *Contemporary Art Review Los Angeles*, July 7, 2016. See https://contemporaryartreview.la/ed-bereal-speaks/.

20 Bereal recounts this vivid, life-changing experience of August 14, 1965, during the Watts Rebellion, in a variety of published sources. One of the most detailed personal accounts is "In Search of Ms. America: An Autobiography of the Watts Years, 1965–1975," in a special issue on art and politics in Los Angeles, ed. George Herms, *New Observations* 92 (Nov.–Dec. 1992): 18–25.

21 Ibid.

22 Telephone interview with Ezrha Jean Black, August 9, 2011, as referenced in the exhibition catalogue *Best Kept Secret: UCI and the Development of Contemporary Art in Southern California, 1964–1971* (Laguna Beach, CA: Laguna Art Museum, 2011), 42.

23 "Oral History Interview with Ed Bereal," Feb. 13, 2016, Archives of American Art, Smithsonian Institution, Washington, DC.

24 A detailed description of *America: A Mercy Killing*, found in an April 2010 audio interview between the artist and Smithsonian American Art Museum curator Virginia Mecklenburg and other museum staff.

25 Ed Bereal, as described to moderator Malik Gaines for Bodacious Buggerrilla's reunion performance at the Getty, Los Angeles, on the occasion of the Pacific Standard Time exhibition initiative, January 2012.

26 For more information on these and other street theater groups of the 1960s and '70s, see John Weisman, *Guerrilla Theater: Scenarios for Revolution* (New York: Anchor Press, 1973).

27 Ibid., 4.

28 Ibid., 89.

29 Benjamin Lord, "Ed Bereal Speaks."

30 Ibid.

31 Ibid.

32 Ibid.

Fig. 32
Miss America: Manufacturing Consent: Upside Down and Backwards, detail
2000–2015
Mixed media and found object
10 × 12½ × 16 ft.
Courtesy of the artist
Photo: Courtesy of Harmony Murphy Gallery, Los Angeles

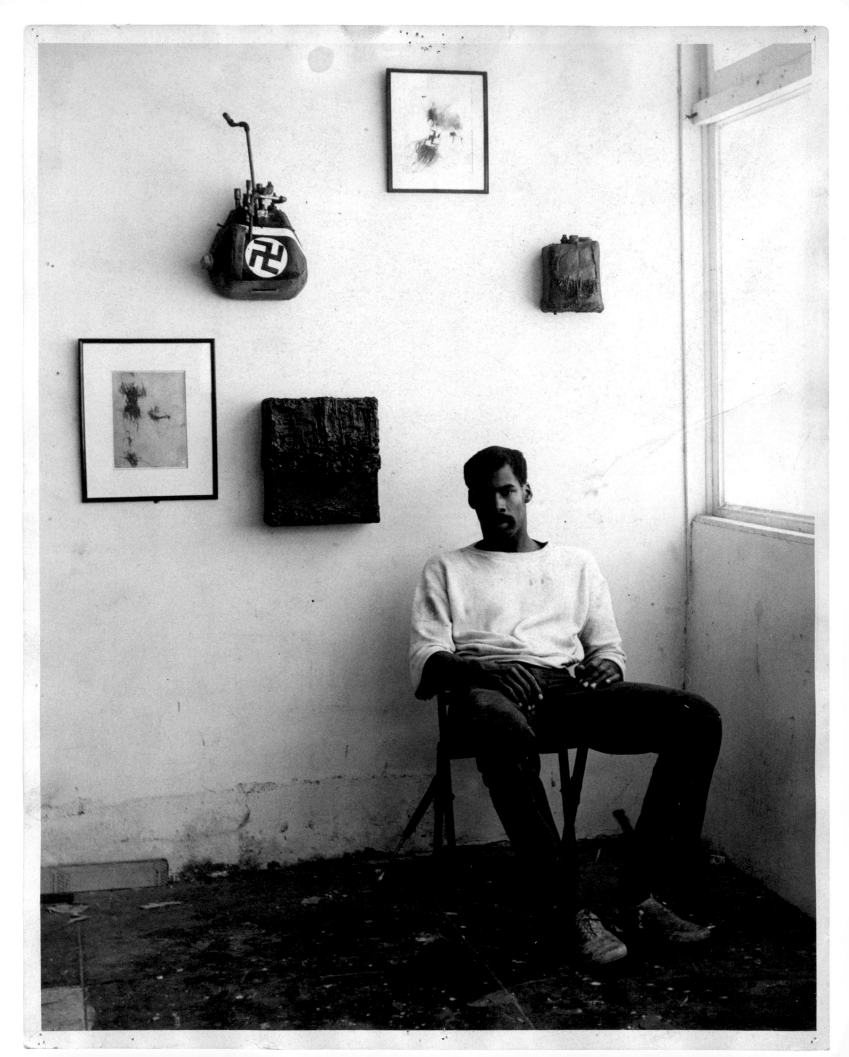

ED BEREAL: DRAWING BETWEEN THE BOXES

Matthew Simms

A photograph of the artist Ed Bereal, taken in 1961 by his friend Jerry McMillan, shows him seated confidently in his Los Angeles studio (fig. 1).[1] On the wall behind him, bathed in soft sunlight spilling in from a window on the right, hang three recent assemblage constructions. Moving in a counter clockwise direction from lowest to highest, they trace Bereal's developing challenge to the conventions of painting, announced first by his use of unusually shaped stretcher bars and then deepened by his addition of pipe fittings and other assorted plugs—industrial touches that trouble the boundary between high art and mechanical equipment. A prominent, reversed swastika emblazoned upon the highest-hung and newest piece introduces yet more ambiguity through apparent if deceptive associations with Nazism. As a group, they suggest military hardware, such as helmets, canteens, rucksacks, and fuel canisters. By extension, they also call to mind manual activities of carrying and wearing, opening and closing, and so on. Corporeal analogies accrue effortlessly to the vaguely organ-like shapes. These "powerful fetish objects," as art critic John Coplans described them, appearing in reproduction in the pages of the widely read monthly *Artforum*, or exhibited in the notorious *War Babies* show at the Huysman Gallery, were some of the most progressive and confounding aesthetic statements then visible in Los Angeles.[2]

Bereal liked McMillan's photograph, which is evident in its faded state and the clusters of tiny pin marks on the print's top edge and corners, indicating that it was frequently on display. Two drawings can also be seen hanging on the studio wall in the photograph. Framed and matted, the pair may have been included in the *War Babies* show, but it is impossible to be sure because there was no checklist and the few surviving installation shots are inconclusive. Bereal's activities as a draftsman, in fact, share in the somatic orientation of his sculpture. Drawing, for Bereal, was first and foremost a record of physical contact with a paper surface accomplished with a range of sharply tipped instruments, from graphite pencils to ink pens. The French writer Paul Valéry once exclaimed that the artist "takes his body with him."[3] This was certainly true for Bereal, but with an important caveat. If Valéry could speak with empyrean universality, Bereal had no such luxury. For Bereal, the body was always already marked with historical, cultural, and above all, racial specificity.

Bereal's earliest surviving drawings occupy the pages of two spiral-bound, all-purpose Morilla sketchbooks, most likely purchased in the late 1950s at Paschke's Gallery, an art supply store on Main Street in his home town of Riverside, California.[4] He began filling the notebooks with drawings while attending art courses at Riverside City College, where he was a student from 1956 to 1958; he continued to add to their number in late 1958 after moving to Los Angeles to attend Chouinard Art Institute. As a group, these sketches and studies chronicle Bereal's progressive mastery of the conventions of life drawing. Academic

Fig. 1
Jerry McMillan
Untitled (Ed Bereal Seated in Studio, Los Angeles)
c. 1961–1964
Silver gelatin print
14 × 11 in.
Courtesy of the artist
Photo: Jerry McMillan,
Courtesy of Craig Krull
Gallery, Santa Monica,
California

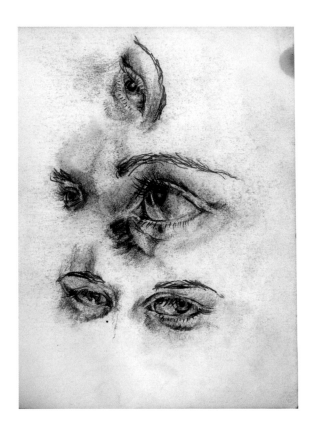

nudes, rendered either in anatomical detail or in overall form, are redolent of the life drawing class (in one drawing, we glimpse the profile of a fellow student working on his own rendition of the nude). Additional studies in the sketchbooks focus on details ranging from expressive heads and eyes to isolated renderings of noses, mouths, and even ears (fig. 2). A trip to the Los Angeles Zoo resulted in a group of rapid sketches— what the French call *croquis*—of captive fauna at rest or in movement (figs. 3 and 4). Finally, Bereal also made studies of hands, some of which take as models the hands of other people and, in one case, what appear to be those of a child. The vast majority, however, depict his own left hand, pressed into service as a readily available model for the right-handed draftsman. One page shows Bereal's left hand twice: at the top of the sheet, it appears as it extended into his field of vision in front of him, open-palmed, digits splayed, and reaching mysteriously into space; at the bottom of the page, the hand reappears, this time in mirror reflection, fingers now drawn together as if in preparation for a hand shake (fig. 5).

For Bereal, such sketching exercises represented a kind of discipline, a daily drawing regimen that sharpened his habits of seeing in terms of perspective, modeling, foreshortening, proportion, and the like. Manuals published in the 1950s stressed the importance of such pencil work while reinforcing the idea that drawing was primarily a means to externalize visual experience. Andrew Loomis's popular manual, *Successful Drawing*, declared that drawing was nothing short of "vision on paper." "More than that," Loomis continued, "it is individual vision, tied up with individual perception, interest, observation, character, philosophy, and a host of other qualities all coming from one source."[5] As with Valéry's comment, cited above, here too the unspoken assumption is that the artist was a white man like Loomis himself and that, as such, he stood as a universal subject for all readers of the book. The assumption of "normative whiteness," to use the vocabulary of critical race theory, extends to the presumption that models would also be white and, therefore, rendering their skin and features called for a tonal scale that used black for

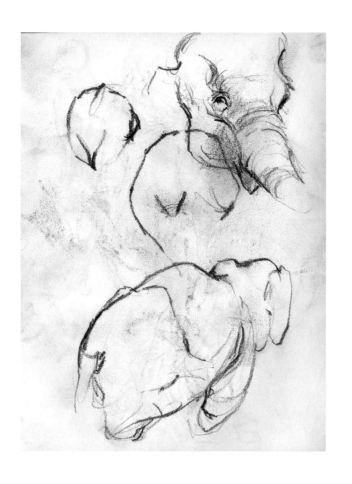

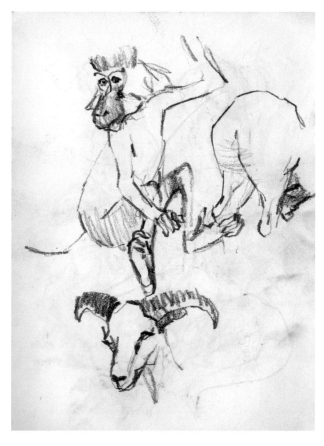

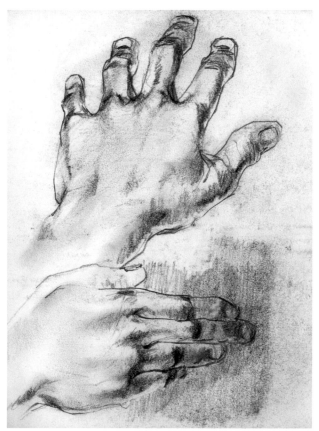

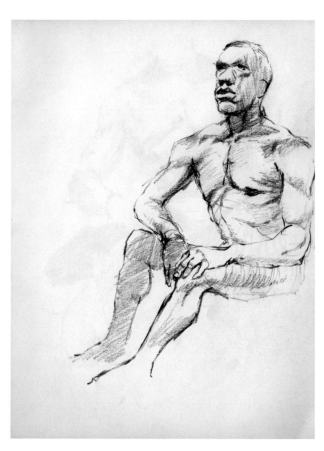

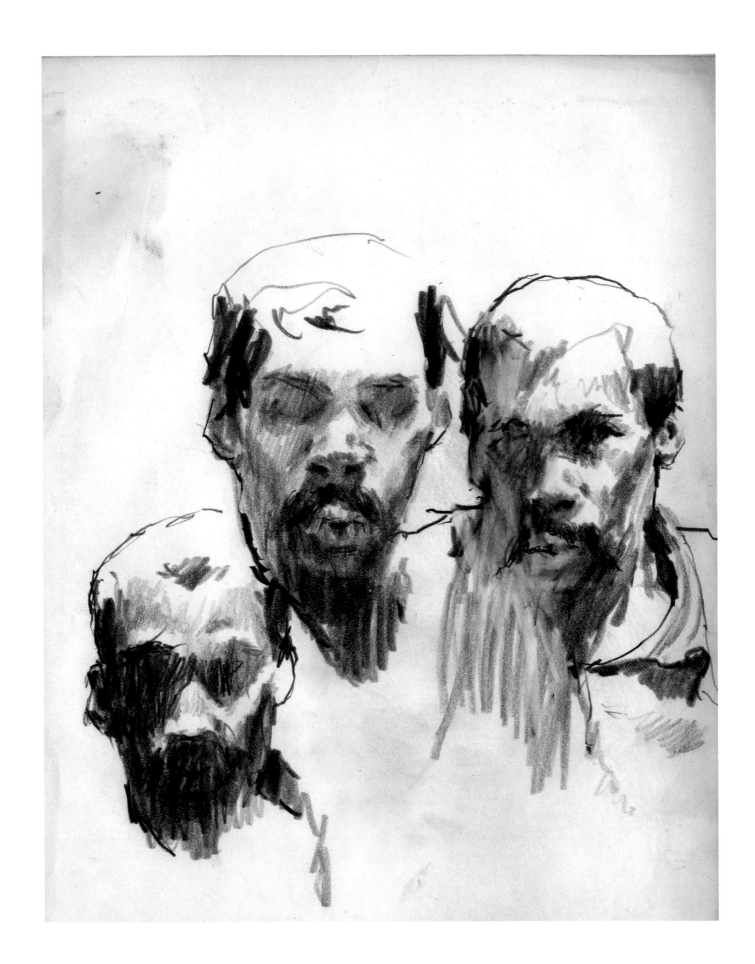

MATTHEW SIMMS

shadow and the exposed white paper for skin.[6] Bereal and, certainly, all persons of color reading such a book, implicitly stood outside this presumably universal subject position as nonwhite, racialized others. Indeed, at Chouinard, Bereal understood that the combination of his race and socioeconomic background set him apart from most of his peers. "My art," he explained, "was a kind of cultural statement, coming from somewhere else."[7]

It is noteworthy that the first model to appear in Bereal's sketchbook is a black man, although there is no evidence that Bereal specifically gravitated toward him because of racial sympathy or what could have been comparable experiences of discrimination (fig. 6). For his part, Bereal tells of how he was denied admission to Art Center School, in Los Angeles, because of racial prejudice, a slight that he later understood to be a blessing in disguise because it led him to enroll at Chouinard.[8] No specific views on these matters can be found in notes or drawings in his sketchbooks. In fact, Bereal seems to move freely from model to model, sensitively rendering both Caucasian and African American men and women in pencil drawings and oil pastels. Neither discrimination nor the false universalism of drawing manuals prevented Bereal from either pursuing his drawing studies with zeal or from developing an astonishing degree of mastery as a draftsman.

Bereal's hand studies employ modeling differently than the technique proposed in Loomis's manual, starting with a dark ground tone for skin instead of using the white of the paper. Bereal favored soft graphite pencils, ranging in grade from 6B to 8B, which allowed him to generate effects of rich, light-absorbing darkness, and by means of which he could transpose the mahogany hues of his skin into the velvety tones of his drawing. This is true also of Bereal's self-portrait studies, of which there are over fifty pages among his early drawings. In one, perhaps made using the same mirror he utilized to draw his hand, he rendered his head no fewer than three times with quickly jotted contours and tonal modeling (fig. 7). The three views, staggered in successive positions across the page, show the artist's head in slightly different attitudes, either looking straight on or turned slightly to the right (the viewer's left). They may have been executed in a single, continuous sitting, given what seems to be a common light source and an overall unity of style. Bereal has varied the weight of his line, twisting his pencil in his fingers, turning it from its thick to its thin edges, and pulling it up, over, and around the form of his skull to give it an emphatic contour. His facial features, conversely, are almost all rendered softly with the flat end of the pencil, which he used to create a Rembrandt-like, light-absorbing tenebrism with coarsely hatched, close-valued tonalities. A faint illumination twinkles in the darkness, thanks to the texture of the paper, which has left a pointillist pattern of tiny white spots, evoking soft, reflected light dimly vibrating in the shadows. The lightness of the page is also recovered by the downward sweeps of Bereal's eraser, which has skidded on the paper and has generated blurry, carved-looking streaks, while a few structural details, such as ear lobes and nostrils, stand out in high contrast, raking light. The same light creates a sheen of unbroken luminosity on the crown of Bereal's head, a glowing halo that opens the artist's body to the flood of unqualified luminosity that surrounds it on the rest of the undrawn paper surface. The whiteness of the page does not, in Bereal's drawing, represent the local hue of the skin, but rather those places where that local hue has been washed out in the glare of reflected light.

Bereal took obvious delight in the unfolding, haptic time of drawing, both in the cadenced interface between hand, pencil, and page and in the multiple, overlapping renderings of his face. This is not a matter of quantitatively measurable clock time but rather of qualitatively felt, embodied time. It is a time that

Fig. 7
Untitled (self-portrait)
c. 1958–1965
Graphite on paper
11 × 8½ in.
Courtesy of the artist

Fig. 8
Untitled (self-portrait)
c. 1958–1965
Graphite on paper
11 × 8½ in.
Courtesy of the artist

surfaces in the pulses and rhythms of the artist's flesh (fig. 8). Bereal's preferred analogy for this lived time is syncopation. "That happens quite a bit when I'm drawing," Bereal explained. "When I really hit a groove, I can just go *zeeee dat-dat-dat-dat-dat*." Gesturing with his hand, as if drawing, and bouncing from one spot to another, he continued: "You're going *da-da-da-da BOOM, da-da BOOM, da-da-da-da BOOM, da-da BOOM* . . . yeah, it's like *BOOM, da-da BOOM*—syncopation." Bereal elaborated, referring specifically to his self-portraits:

> I'm on the side of the pencil, and I come back with an eraser and I start to indicate lips. Okay? And maybe slash a little bit through here, and then I'm on the side of my pencil, and then I come up on the end of it and hit the dark spots. . . . You're going soft, hard, medium . . . it's a *BOOM, pa-pa-pa-pa BOOM, pa-pa-pa-pa-pa-pa-pa BOOM, pa-pa BOOM*. So, I'm going *da-da-da-da-da-da-da-da-da-BAM! Da-da-da-da-da-da-BAM! Da-da-da-da* . . . and every time I hit it, I hit it on the edge, and that's where it starts to get black.[9]

Drawing, for Bereal, is rhythmic figuration, in which movements of the pencil become like improvisational beats and rhythmic pulses. Verbalizing his drawing technique, he falls into a spoken mimicry of tempos that he associates with jazz and blues. Bereal's vocal intonations, as articulated in repeated sounds, parallels and analogizes the repeated strokes of his pencil.

Consequently, we might say that we listen to Bereal's self-portrait drawings as much as we behold them. This is not a deciphering kind of listening, in which we try to detect a hidden message, but rather a

flowing acoustic resonance, a carnal vibration, that invites the viewer to resonate sympathetically with the patterns and gestures of Bereal's tactile engagement with the page. We hear the presence of his body, in other words, as much as we can see it. In the triple self-portrait, Bereal too seems to be attentively listening as much as he is carefully looking. Or, to be more precise, he is listening, looking, and manipulating a pencil all at the same time. Vision is, in fact, somewhat downplayed in these self-portrait drawings, eyes disappearing into dark, shadowy sockets. This allows other senses to come forward, like touch and hearing. Once again, however, as in his drawings of his hands, Bereal's body emerges as specific not universal. His body, and the experience it houses, is that of a young African American man from Riverside, California. This culture, which comes from "elsewhere," as he put it, was also open to musical metaphor. "My culture is like the blues," Bereal noted, "raw not cooked."[10]

By the time he entered his second year at Chouinard, Bereal had mastered the conventions of figure drawing and was beginning to hunger for something new. He had, in fact, become confident enough about his drawing skills that he could challenge his instructors. One teacher, he recalled, announced after posing a model that a successful drawing of the subject would take at least two days. Pulling his drawing bench up close, so all the other students could see his work, Bereal banged out a perfect drawing in less than an hour. "And I'm sitting there real close," he explained, "but I know everybody behind me can see what I'm doing, so I knock out a killer drawing, and I get up and go have some coffee, and let [them] look at what it's supposed to look like."[11] Bereal's bluster, however, was counterbalanced by the humbling experience, around the same time, of walking into Robert Irwin's classroom and discovering an entirely new visual vocabulary. "I was kicking ass in the illustration area," he explained, "and I made the fatal, fatal mistake of having to walk down the hallway, and I walked past Bob Irwin's painting class." He continued:

> And I walked by that door, and I went, "What's that? What are they doing? What's that all about?" And he was talking and saying some stuff, and I'm going, "Whoa. That's interesting." . . . These guys are talking about stuff that was outside my realm, not of understanding, but of exposure.

"I'm thinking, you know, this is—I don't have the obligation to do representational work," Bereal concluded, speaking of his drawings and paintings. "I can let this be a thing, an object, an event."[12] Bereal wound up taking courses with Irwin, Richards Rubin, and Emerson Woelffer, three instructors who exposed their students to developments in New York School abstraction and European tachism. Bereal recalled being roused by discussions in these classes, as well as by the kind of work these instructors were showing, including that of Franz Kline, Antoni Tàpies, and Cy Twombly, all of whom had turned their backs on figurative rendering in favor of gestural mark-making for its own sake.

Bereal returned to his drawing paper and pencils, rediscovering the page as a bright surface for accumulating what now became dark and dissolving thickets of inchoate, inarticulate graphite scribbles. He prepared his sheets by fully or partially soaking them in shallow baths of mineral spirits so that the already soft graphite of his pencil would disintegrate as it came into contact with the now oily and reeking paper support. In some of these drawings, we can barely make out the contours of a female nude, suggesting that Bereal was not yet willing to drop entirely a representational point of origin (fig. 9). In short order, however, as can be seen in a pair of related drawings both dating from around 1960, he abandoned

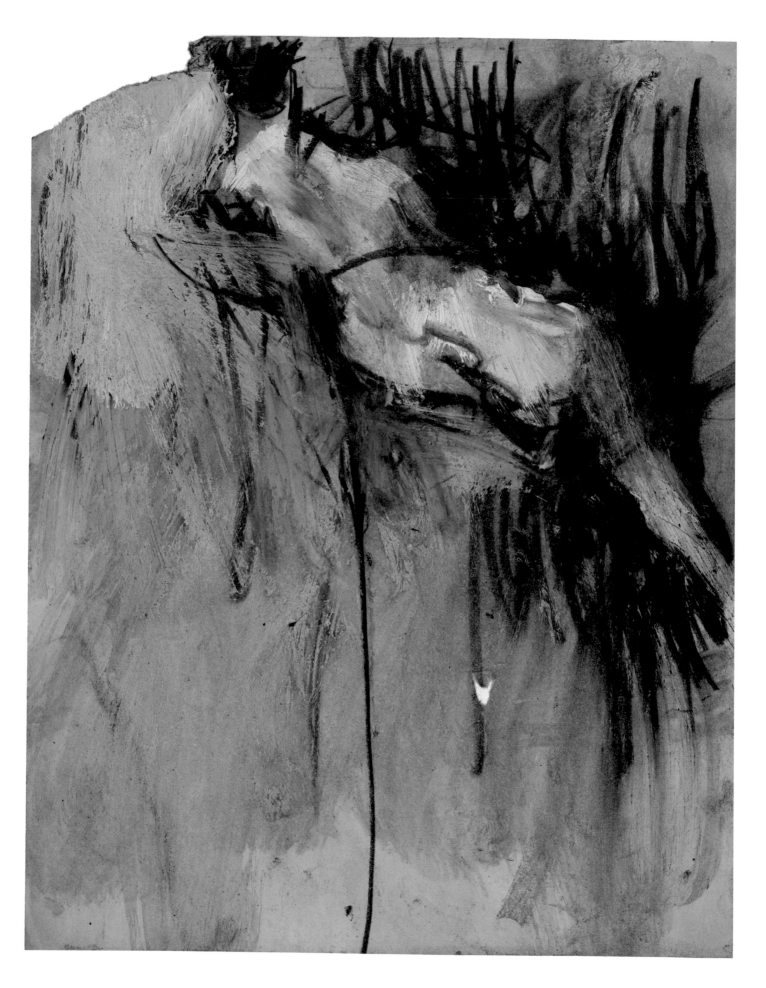

Fig. 9 (opposite page)
Untitled
c. 1958–1965
Graphite and paint on paper
11 × 8½ in.
Courtesy of the artist

Fig. 10 (above left)
Untitled
c. 1958–1965
Graphite on paper
11 × 8½ in.
Courtesy of the artist

Fig. 11 (above right)
Untitled
c. 1958–1965
Graphite on paper
11 × 8½ in.
Courtesy of the artist

figuration entirely, transforming the page into a scratchy, murky record of manual effort, the pencil transferring the downward pressure of the hand to the toothy field of paper fibers, grabbing, slipping, jerking, or sliding as it deposited at times granular, at times dark, ink-like streaks onto the page (figs. 10 and 11). Itineraries of inscription can be traced in both of these drawings as the artist's hand and pencil moved part by part over the paper surface, creating clumps of pencil strokes in certain areas.

It is this kind of abstract, gestural drawing that can be seen hanging framed on the studio wall in McMillan's photograph of Bereal. From the smoky, oily depths of these inarticulate marks, however, emerge the surprising yet recognizable shapes of swastikas, rendered in mirror reversal. The backward swastikas appear from the clusters of claw-like pencil scratches, partially liquified by the spirits-soaked paper, like spiders crawling across sticky webs, sometimes becoming reabsorbed into the graphic chaos either in part or in whole. The swastikas take place in these drawings not as symbols but as events of graphic coalescence and dissipation. They appear as slowly resolving and dissolving scrawls that play around the boundaries of meaning and nonmeaning, flirting with semiotic coalescence and collapse. On the other hand, as swastikas of any kind—reversed or otherwise—they provoke recognition and interpretation. To be clear, Bereal harbored no sympathies for the racist views of Nazism, but he gladly toyed with this powerful and taboo symbol. Bereal was satisfied enough with the shock effect of the backwards swastika motif that he adopted it in some of his assemblage constructions, as can be seen in McMillan's photograph. He also included the motif in a series of contemporary ink drawings, underscoring just how widespread it became in his early graphic practice (fig. 12). In notes penned in 1963, just after completing his studies at Chouinard, Bereal admitted to a profound fascination with the power of visual phenomena that could arrest and compel attention, but in a purely physical way. He spelled out this attraction to visual force by means of contrast to the imagery of Pop Art:

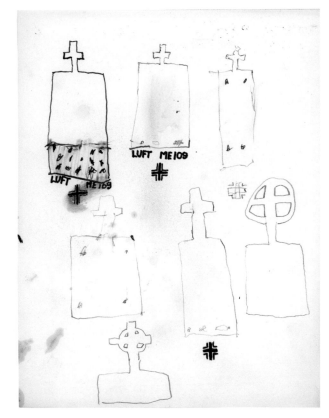

I was thinking—nowadays painters are trying to shock and impress [the] viewer in a conceptual area. In effect still saying as the Dadaist said, this too is art, whether a urinal as done by Duchamp or a movie star or comic strip as in Warhol or Lichtenstein. This is fine, except, what happens when the idea is lost or forgotten? Where is the picture? I found myself in an area which attacks the viewer physically regardless of his conceptual patterns—today, tomorrow, or while f[***]ing. If he has eyes, I've got him.[13]

Bereal's colorful phrasing underscores the kind of startling intensity he was trying to achieve. Certain symbols, retooled or repurposed, packed a gut-level punch. The meaning of such symbols interested him less than their potential for somatic impact, crashing through a rattled sensorium. Gathering strength on the page, they surge forth and seize the viewer by the eyes.

This is one way to understand Bereal's attraction to the taboo form of the swastika. And, in fact, we witness a similar kind of symbolic play in a subsequent, related series of drawings, dating from 1962 to 1963. Made as brainstorming for new shapes and configurations for his three-dimensional work, these drawings take up equally freighted cruciform designs. Some of the pages present nothing more than crude outline drawings, while others attempt to render the sculptures in three dimensions. Still others are drawn extremely precisely, as if with a straight edge, including occasional holes torn or dug through the paper surface. As the drawings multiply, the crosses on rectangular bases begin to resemble tombstones, with either Christian crosses or Celtic variants sprouting from their tops. The cross eventually mutates into the *Balkenkreuz*, or bar cross—the insignia of the German armed forces in both the First and Second World Wars. In many of these drawings, the German cross is accompanied by what look to

Fig. 12 (above left)
Untitled
c. 1958–1965
Asphalt on paper
15 × 11½ in.
Courtesy of the artist

Fig. 13 (above right)
Untitled
c. 1958–1965
Graphite on paper
12 × 9½ in.
Courtesy of the artist

Fig. 14 (opposite page)
Untitled
1967
Ink on paper
11¾ × 8¾ in.
Courtesy of the artist

be serial numbers, as if copied directly from an aviation encyclopedia.[14] Embellished with collaged paper additions, or taken up again in pen and ink drawings dripping with splatter patterns, German and Christian crosses became yet more elements in Bereal's arsenal of attention-compelling imagery (figs. 13 and 14). Swastikas and crosses function like visual detonations, or explosions, that blow up in the viewer's perceptual field but refuse to become easily assimilated to familiar categories. They are, to continue the metaphor, like depth charges, which erupt beneath the surface of thinking, creating sensory turbulence that disrupts conceptual coherence.

And yet, meaning is not entirely forestalled—Bereal's attraction to swastikas and crosses was clearly based, in part, on their emotional resonance. In addition to their perceptual impact, Bereal's swastikas and mutating crosses summon the malignant iconography of white supremacism. The intentional structure built into these drawings, however, belongs not to a white supremacist but to a young African American man. Bereal's unique perspective is housed in an empirically specific body, temporalized by deep, rhythmic pulsions. All of this is as much on display in the haptic mark-making of his abstractions as it is in his figurative renderings. The specificity of Bereal's intentional perspective—what, borrowing a phrase from philosopher Linda Martín Alcoff, we might term Bereal's "phenomenology of racial embodiment"—radically complicates whatever meaning we might want to assign to his play with racist symbolism.[15] Bereal's marginal position, as he put it, "coming from somewhere else," meant that he was

free to treat the grand narratives and symbolic connotations of the mainstream as foreign to his own frame of reference. This independence resonated on several levels. On the one hand, Bereal bristled when he was asked to choose between figurative and abstract art. By the time he enrolled at Chouinard, the art world was already organized into the opposed realms of illustration and fine art; within fine art, it was divided again between the figurative and abstract artists; within abstraction, the choice lay between either scruffy assemblage or clean hard-edge painting, and so on. Embracing both figurative and abstract styles—both illustration and fine art—and both assemblage and hard edge styles, Bereal refused to fit into any externally imposed category. "I was never content just to accept the rules," he explained, "and I was very quickly drawn to opportunities to resist or revolt against them." "I wasn't interested in occupying a certain conceptual box," Bereal added, "I wanted to see what happened between the boxes."[16]

Bereal's independence also meant that he could arrogate to himself the freedom to rechristen swastikas and crosses with personal meanings, while pointing beyond them to questions of racial politics that were becoming important to him as his perspective expanded and as his work matured through the decade of the 1960s. Indeed, what Bereal increasingly discovered "between the boxes," as it were, was nothing other than his own position on the margins of a dominantly white art world, in which he was beginning to feel more and more uncomfortable. The alienation was suddenly intensified by the Watts Rebellion in the summer of 1965, a three-day uprising that Bereal has described experiencing first as a smell of smoke in the air and, by the end, as the sight of national guardsmen pointing guns in his direction.[17] He made no drawings in response to the uprisings, however, as if needing time to sort through his thoughts and emotions. In May 1966, Bereal took up his pencil again, this time while watching the eight-day, televised coroner's inquest into the shooting death of an African American motorist named Leonard Deadwyler, by a white police officer who claimed his pistol had gone off accidentally.[18] Pencil in hand, Bereal jotted the faces, heads, and expressions of the witnesses as they delivered testimony, one by one, resulting in a gallery of clench-jawed police officers on the one side, and the dead man's bereft widow on the other (fig. 15). Bereal's drawings of the hearings foretell a change in his art, starting with a calibration of his pencil to the pulse of current events. Bereal's Deadwyler drawings capture a moment when his gaze coincided with those of thousands of other Americans simultaneously watching the proceedings on their television sets. The spectacle of Deadwyler's widow on the stand, the contradictory testimonials about what led to the man's death, and the sinking suspicion of a miscarriage of justice provided Bereal with a new kind of gut-wrenching subject matter.

Following the Watts Rebellion, and after the subsequent Deadwyler inquest, Bereal's investigation of racialized embodiment widened beyond the parameters of his personal experience. Setting aside drawing, at least for a while, he shifted his attention from rendering first-person perception to embracing the multiple and overlapping experiences of the greater Los Angeles area African American community. Through engagement with participatory street theater, public education, and documentary film, Bereal cultivated an ever-widening circle of activities that became the foundation for a new kind of artistic activism. When drawing returned to Bereal's practice, starting in the 1990s, it did so as an integral part of this new artistic identity. As in his early work, in the more recent drawings he set out once more to deliver decisive blows to the viewer's sensorium, but now through the depiction of institutional racism and corporate greed (fig. 16). "If he has eyes," Bereal could still declare of his viewer, "I've got him."

Fig. 15
Untitled
1966
Graphite on paper
11 × 8½ in.
Courtesy of the artist

BARBara Deadwyler

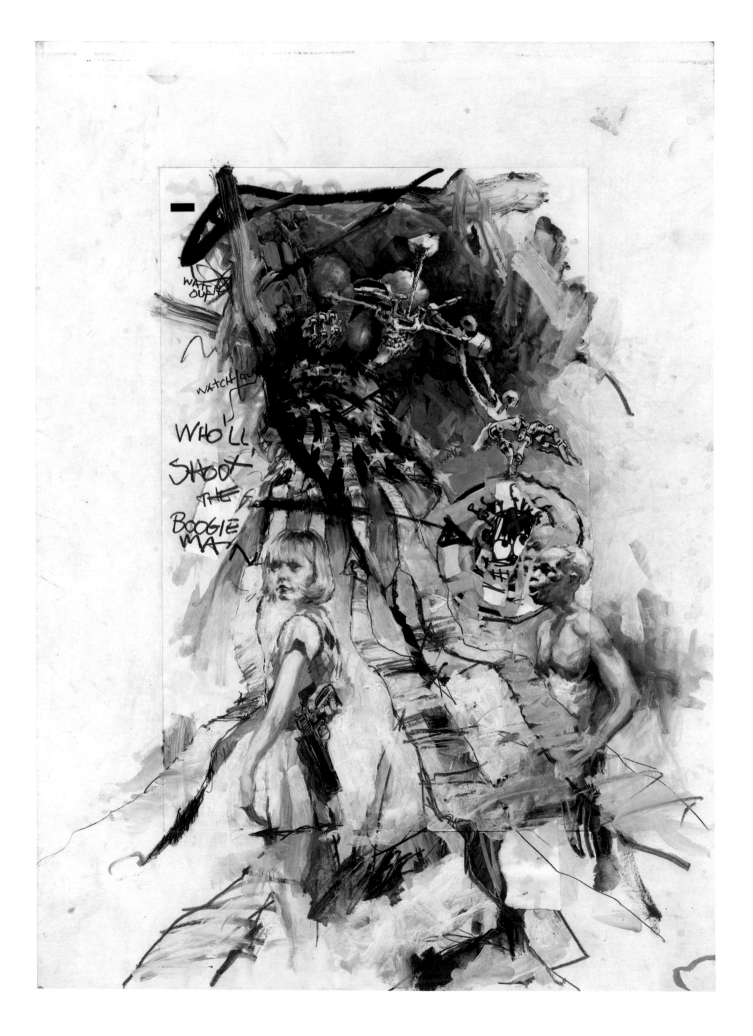

NOTES

I would like to express my sincere gratitude to Ed Bereal, Amy Chaloupka, Barbara Matilsky, and Barbara Sternberger for giving me the opportunity to be part of this project. Additional thanks are due to Amy Chaloupka and Jeffrey Ryan for offering crucial feedback on the text.

1 Jerry McMillan made several photographs during the visit, including two others that show Bereal standing, legs akimbo, and leaning on the back of the chair.

2 John Coplans, "Sculpture in California," *Artforum* 2, no. 2 (Aug. 1963): 4.

3 Paul Valéry, cited by Maurice Merleau-Ponty, "Eye and Mind," in *The Merleau-Ponty Aesthetics Reader: Philosophy and Painting*, ed. Galen A. Johnson, trans. Michael B. Smith (Evanston, IL: Northwestern University Press, 1993), 123.

4 One of the two sketchbooks has a red Patschke Gallery stamp on its cover.

5 Andrew Loomis, *Successful Drawing* (New York: Viking Press, 1951), 11.

6 See Cleavis Headley, "Delegitimizing the Normativity of 'Whiteness': A Critical Africana Philosophical Study of the Metaphoricity of 'Whiteness,'" in *What White Looks Like: African American Philosophers on the Whiteness Question*, ed. George Yancy (New York: Routledge, 2004), 95.

7 Ed Bereal, interview with the author, March 30, 2019.

8 "Oral History Interview with Ed Bereal," Feb. 13, 2016, Archives of American Art, Smithsonian Institution, Washington, DC.

9 Ed Bereal, interview with Amy Chaloupka and the author, March 10, 2019.

10 Ed Bereal, interview with the author, March 30, 2019.

11 "Oral History Interview with Ed Bereal," Feb. 13, 2016, Archives of American Art, Smithsonian Institution, Washington, DC.

12 Ibid.

13 Ed Bereal, untitled notes dated Nov. 13–14, 1963, collection of Ed Bereal.

14 Bereal owned a wartime edition of *Jane's All the World's Aircraft,* ed. Leonard Bridgeman (New York: Samson, Low, and Marston, c. 1943). See Ed Bereal, interview with Amy Chaloupka and the author, March 10, 2019.

15 Linda Martín Alcoff, *Visible Identities: Race, Gender, and the Self* (Oxford: Oxford University Press, 2006), 179–194.

16 Ed Bereal, interview with the author, March 30, 2019.

17 "Oral History Interview with Ed Bereal," Feb. 13, 2016, Archives of American Art, Smithsonian Institution, Washington, DC.

18 For contemporary bicoastal news coverage, see Jerry Cohen, "Coroner's Jury to Sift Facts in Police Slaying of Negro," *Los Angeles Times*, May 18, 1966, 3, and 25; and Gladwin Hill, "Widow Testifies on Watts Killing," *New York Times*, May 25, 1966, 29.

Fig. 16 (opposite page)
Untitled (study for *Who's the Boogie Man*)
c. 1998
Oil and mixed media on board
24½ × 17½ in.
Courtesy of the artist

Page 60
Untitled
c. 1958–1965
Asphalt on paper
11 × 8½ in.
Collection of Leslie Jacobson
Photo: Courtesy of David Scherrer

Page 61
Untitled
c. 1958–1965
Graphite on paper
12 × 9¾ in.
Collection of Leslie Jacobson
Photo: Courtesy of David Scherrer

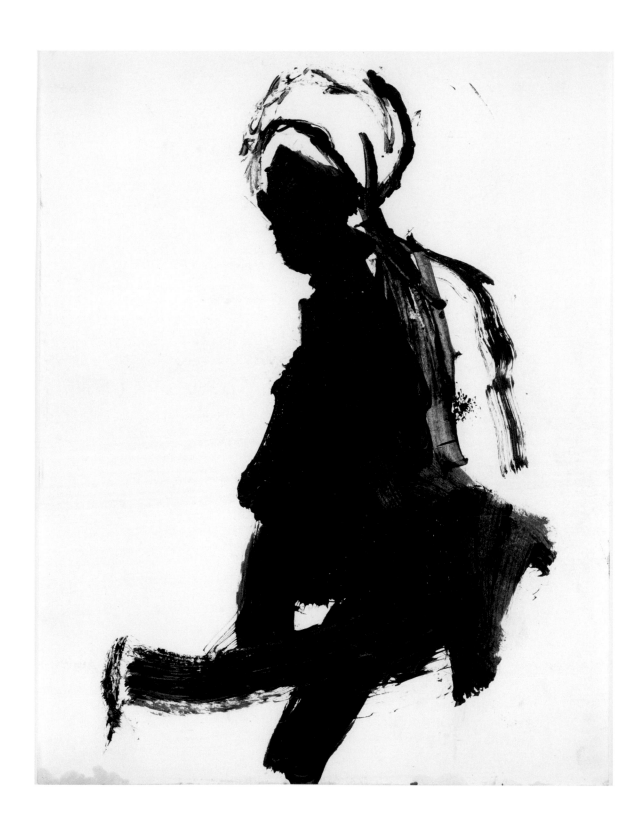

MATTHEW SIMMS

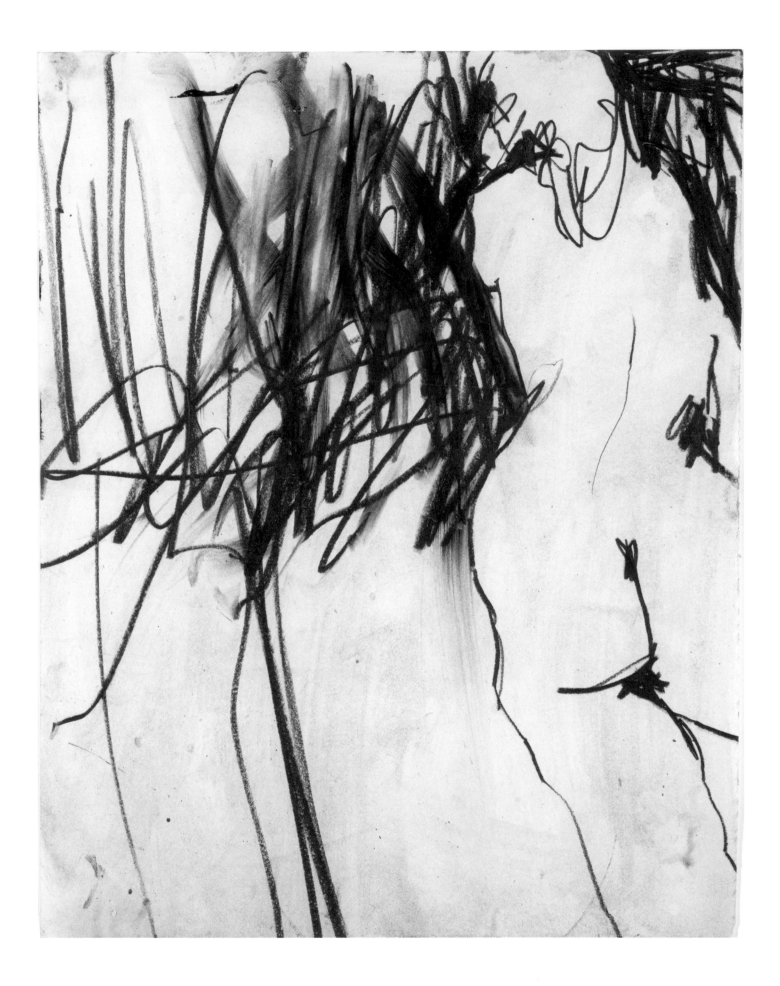

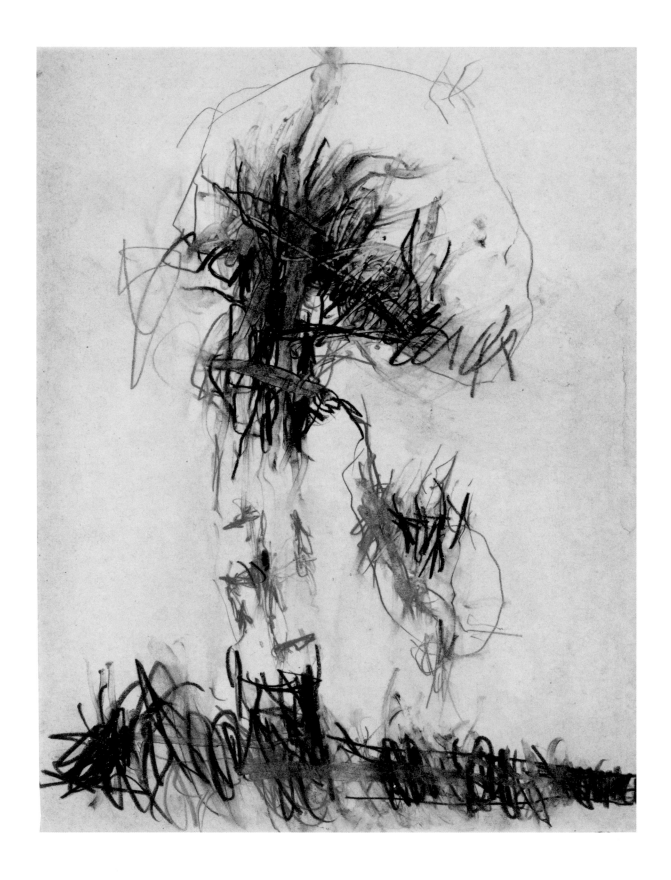

Untitled
c. 1958–1965
Graphite on paper
11 × 8½ in.
Courtesy of the artist

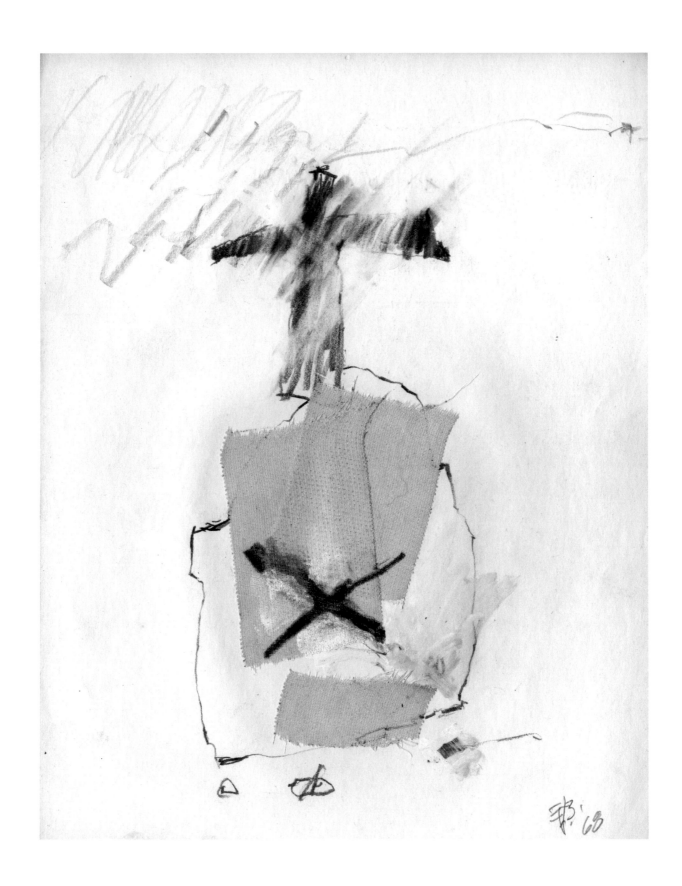

Untitled
1968
Mixed media on paper
16 × 12 in.
Courtesy of the artist

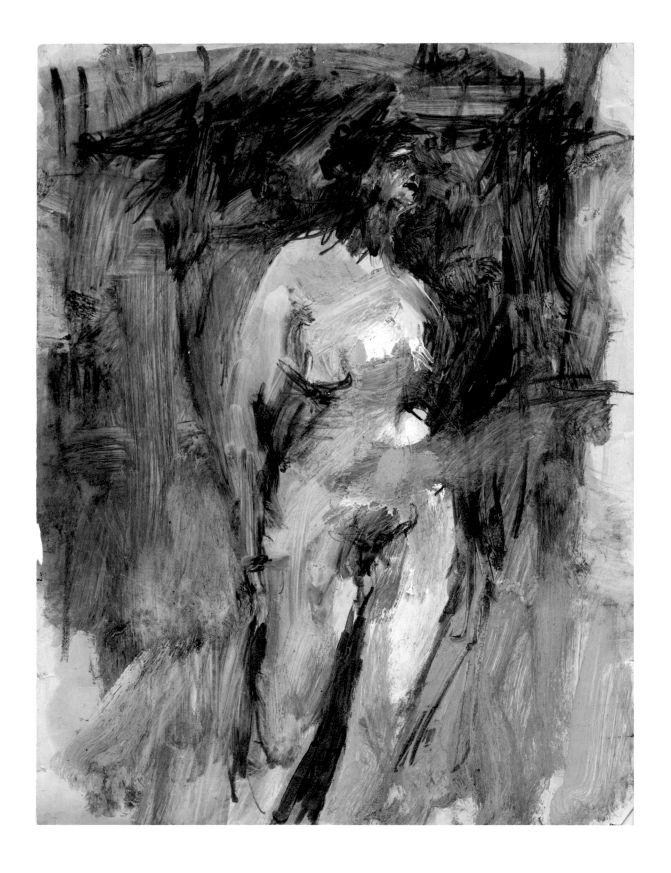

Untitled
c. 1958–1965
Graphite and paint on paper
11 × 8½ in.
Courtesy of the artist

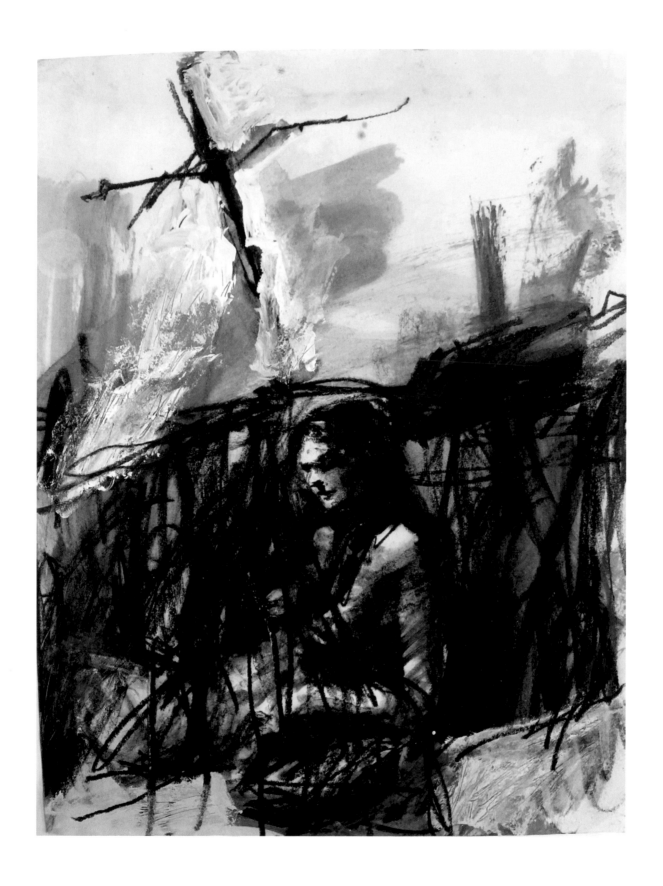

Untitled
c. 1958–1965
Graphite and paint on paper
11 × 8½ in.
Courtesy of the artist

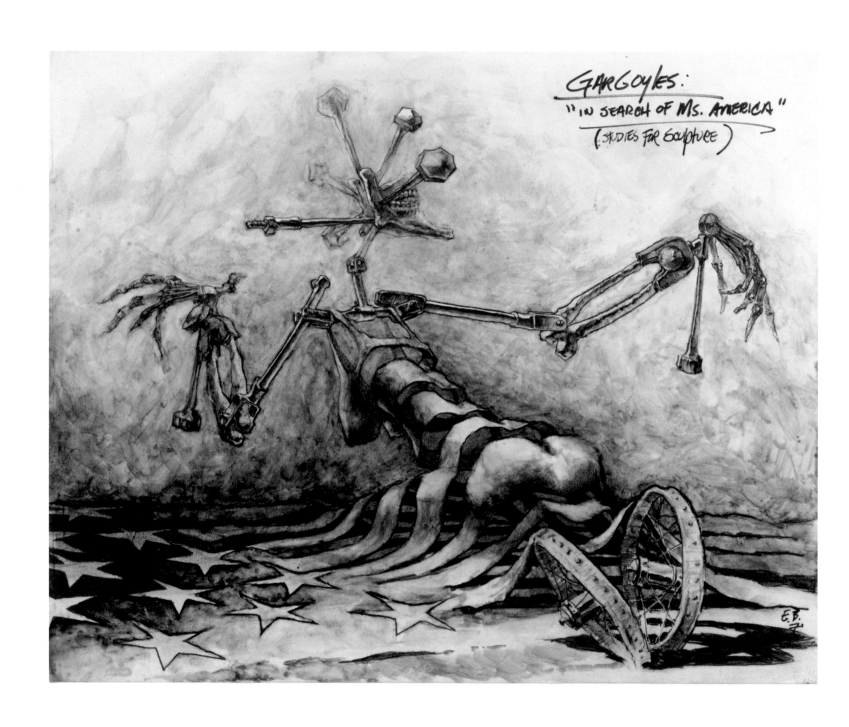

Gargoyles
1992
Graphite on paper
21 × 16½ in.
Courtesy of the artist
Photo: Courtesy of Harmony
Murphy Gallery, Los Angeles

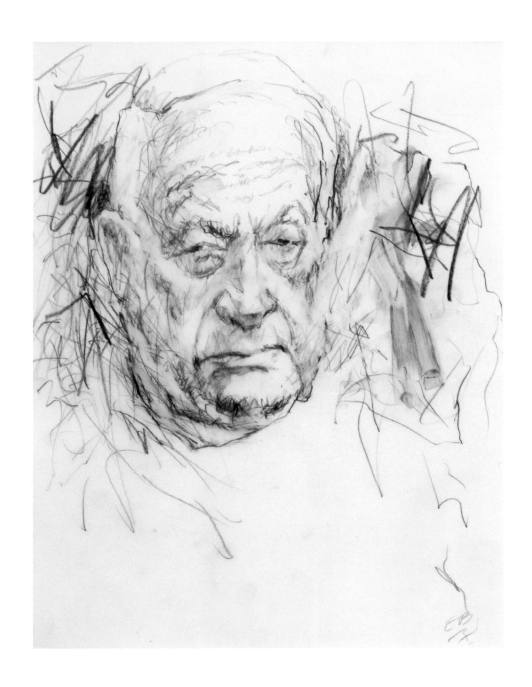

Untitled (Ariel Sharon)
c. 2011
Graphite on paper
13¾ × 10¾ in.
Courtesy of the artist
Photo: Courtesy of Harmony
Murphy Gallery, Los Angeles

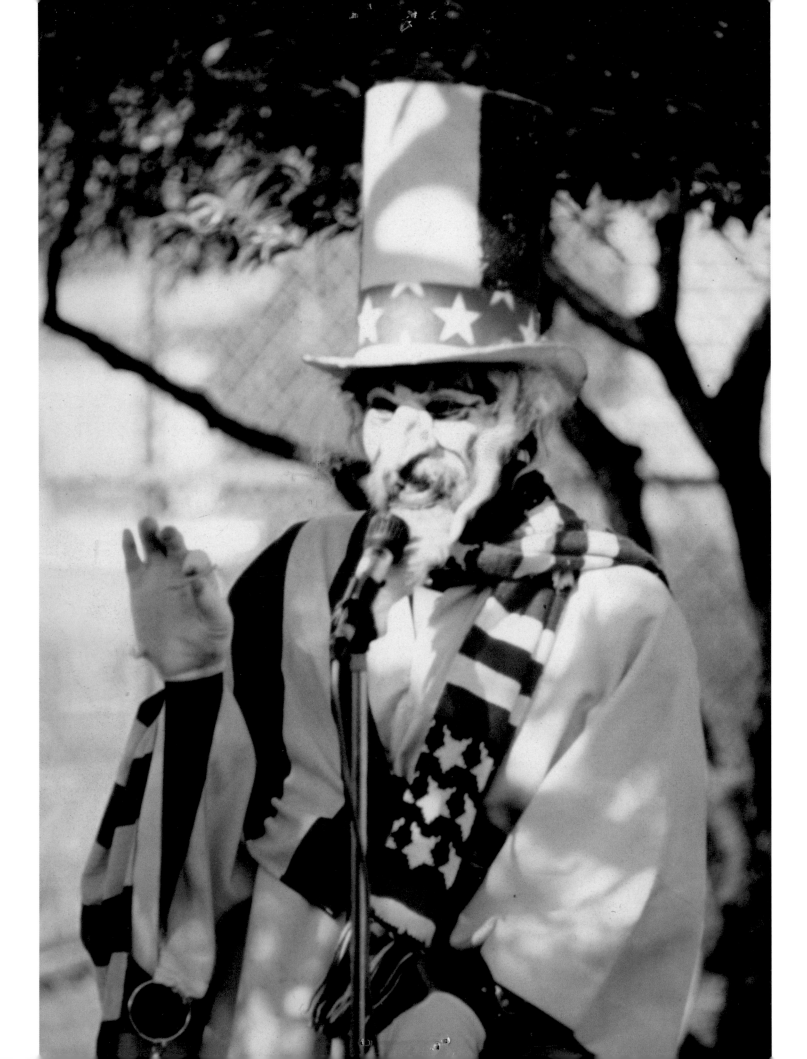

CREATING WITH A PURPOSE: ED BEREAL AND THE BODACIOUS BUGGERRILLA

Malik Gaines

One day in January of 2012, Ed Bereal paced back and forth in a conference room of the J. Paul Getty Museum. He clasped a plastic billy club in one hand and patted it repeatedly against the palm of his other hand, in that menacing way cops did when they carried billy clubs. Curators and administrators were speaking, trying to lay out policies for conducting oneself in the building, embodying the authority of that massive institution, a castle-like arbiter of high art atop a mountain in Brentwood, California. The addressees were reunited members of the Bodacious Buggerrilla, Bereal's theater troupe and black radical collective that performed political satire in South Los Angeles between 1969 and 1975 (figs. 1 and 2). The dynamic was memorable. The institution, caught in its double bind of protecting art culture and enforcing limits around it, invited everyone inside, under the conditions of some mild "policing." Bereal, in a carnivalesque performance, refused that assignment of roles and rerouted the power in the room, billy club in hand. This subtle enactment inside a benevolent institution reflected just a glimmer of the outright radicalism of the Bodacious Buggerrilla's repertoire of performances.

On the occasion of this festival recognizing historic works from Los Angeles, the reunited troupe members—Bereal, Larry Broussard, Bobby Farlice, DaShell Hart, Tendai Jordan, Barbara Lewis, and Alyce Smith-Cooper—performed their play "Killer Joe," which features a set of charged confrontations between sex workers, police, and neighborhood folks, offering a comic ethics (fig. 3). Bereal himself played a "pig," a cop in a grotesque pig mask, reflecting the black critique of white power this group pursued. A fake gunshot from a racist character planted in the audience punctuated the evening with spurts of stage blood. This gag was more than theatrics, but a reference to violence these performers faced in their lives and works. Off stage, many such memories were shared. In a plaza of imported travertine, for example, one member spoke of his time as the bodyguard of Black Panther leader Elaine Brown. Despite the incongruous setting, the group revived a sense of direct political theater, unafraid of hard issues and unconcerned with marketable polish. Heated further by the warmth of the reunion, this was a fully resistant performance.

In the early 1960s, Bereal was an up-and-coming sculptor in Los Angeles, helping to establish the collage and assemblage aesthetic so central to that moment, with objects that were both hard hitting and

Fig. 1
Untitled (Bodacious
Buggerrilla performance still,
Ed Bereal as Uncle Sam)
c. 1968–1975
Archival digital print
14 × 11 in.
Courtesy of the artist

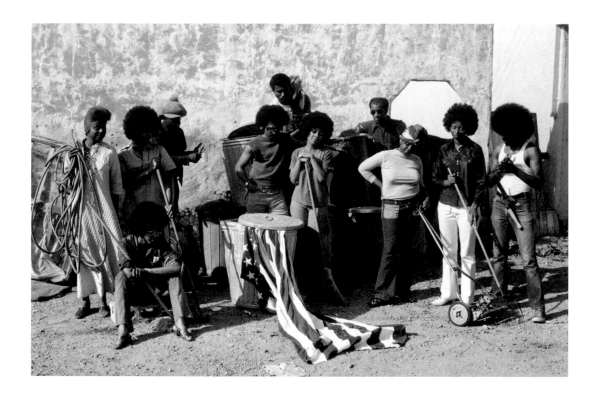

Fig. 2
Untitled (Bodacious Buggerrilla group photograph)
c. 1968–1975
Archival digital print
11 × 14 in.
Courtesy of the artist

Left to right: Sandra Smith, Pamela Donovan, DaShell Hart, Billy Crutchfield, Marlow Thompson, Barbara Lewis, Cliffton Porter, Pat Thomas, Tendai Jordan and Lonnie Chapman
Seated: Joan Ringgold

Those involved with Bodacious Buggerrilla not pictured: Nathanial Ali, Attaulah (Eddie Anderson), Ed Bereal, Donna Brooks, Larry Broussard, Greg Wiley Edwards, Anne Edwards, Bobby Farlice, Alyce Smith-Cooper, George Taylor, Barbara Tramel, Essie Tramel-Seck, Theo Washington, and Sam Williams

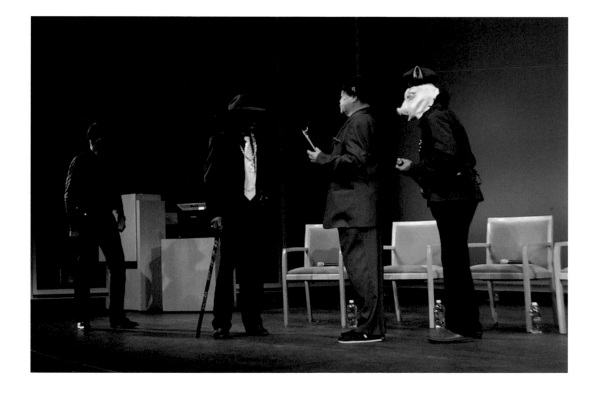

Fig. 3
Untitled (Bodacious Buggerrilla reunion performance of *Killer Joe*)
2012
C-Print
11 × 14 in.
Courtesy of the artist
Left to right: Larry Broussard, DaShell Hart, Bobby Farlice, and Ed Bereal

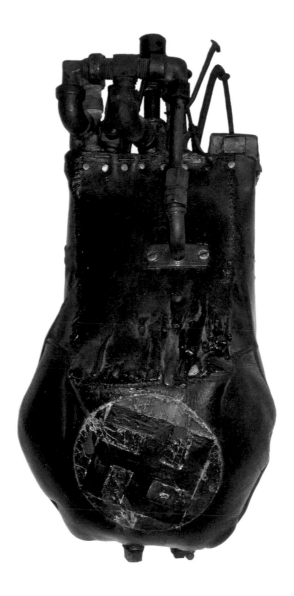

Fig. 4
Junker Ju
1960–1961
Oil paint, leather, nails, and
metal pipes
16 × 8 × 3 in.
Whereabouts unknown
Photo: Courtesy of Laguna
Art Museum, Laguna Beach,
California

elegant (fig. 4). The politicization of the decade eventually revealed the limits of the reach of the art world, as Bereal sought new, more urgent forms of expression.

Bereal has described the art world he was finding success in as "a never-never land,"[1] and has cited the Watts uprising of 1965—and in particular, seeing his own street militarized—as an impetus to leave that world behind, realizing that "if you're not creating with a purpose, it doesn't mean anything."[2] The move toward guerrilla theater offered a different kind of purpose and a more immediate political engagement with black as well as non-black audiences. Bodacious Buggerrilla's plays did not shy away from reflecting the conditions of a racist society and the complexity and complicity its inhabitants face. All of this was done using the best tools of Agitprop, including music, costumes and masks, audience engagement, amateur performers, placards, and simple scenery and staging that could be mounted anywhere (figs. 5 through 7). This work was not fully unusual within the organized and inventive movements of the time, but it offered important distinctions from both high art culture and straight political organizing, much in the manner of unrelated contemporaries El Teatro Campesino and the San Francisco Mime Troupe. Still, the group seems to have been observed by COINTELPRO, the FBI's arm that surveyed and suppressed

productively considered alongside other such gems as Bill Gunn's *Personal Problems* and the works of Ulysses Jenkins, to name only a few. Still, the "bodaciousness" of this work's political address is in its own category.

I was personally involved in the Getty's 2012 revival project as an artist-curator working on that season's Pacific Standard Time Performance Festival. I was directed to the Bodacious Buggerrilla by curator Yael Lipschutz, whose own work was focusing on the legendary assemblage artist Noah Purifoy. Learning about Bereal and the Bodacious Buggerrilla was a revelation to me, and watching those assembled elders work taught me a lot about collaboration and integrity. That experience also reaffirmed for me the idea that the 1960s and its politics are not as far from us as they might appear through our mediated hyper-capitalist American apparatus. Since that time, more and more important artists from that remarkable era are receiving some of the institutional recognition and historicizing that had been denied them. Few of those artists who remain spoke as boldly or as directly as Bereal about the conditions we seek to survive. And now, we must continue to be bodacious.

NOTES

1. John Weisman, *Guerrilla Theater: Scenarios for Revolution* (Garden City, NY: Anchor Press, 1973), 102.

2. Ibid., p. 103.

Fig. 9 (above left)
Untitled (*Pull Your Coat* production still)
1986
Archival digital print
14 × 11 in.
Courtesy of the artist

Fig. 10 (above right)
Untitled (*Pull Your Coat* production still)
1986
Archival digital print
11 × 14 in.
Courtesy of the artist
Bereal plays contestant "Gary," Center

Figs. 11 and 12 (opposite page)
Untitled (*Pull Your Coat* film still)
1986
Video with sound: approx. 27 min.
Courtesy of the artist

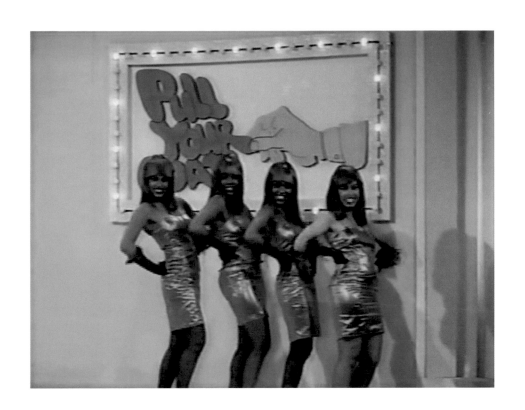

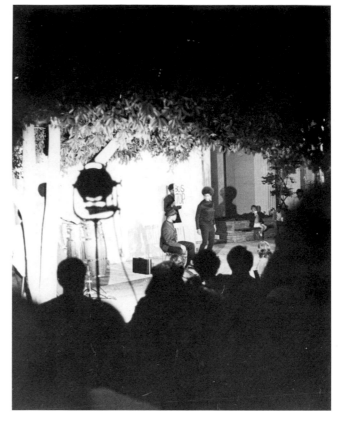

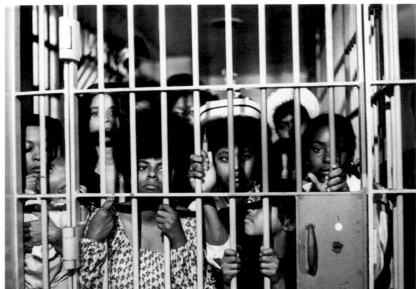

(above left)
Untitled (Bodacious
Buggerrilla performance still
from *Killer Joe*)
c. 1968–1975
Archival digital print
14 × 11 in.
Courtesy of the artist

(above right)
Untitled (Bodacious
Buggerrilla performance
at University of California,
Riverside)
c. 1968–1975
Archival digital print
14 × 11 in.
Courtesy of the artist

(bottom)
Untitled (Bodacious
Buggerrilla publicity shot,
Venice Jail)
c. 1968–1975
Archival digital print
11 × 14 in.
Courtesy of the artist

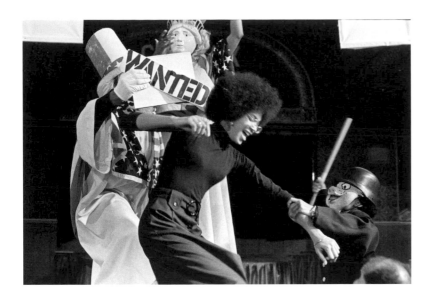

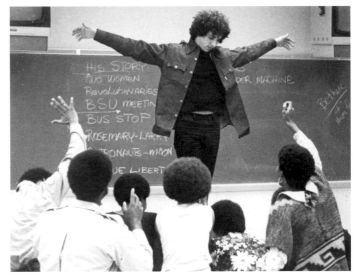

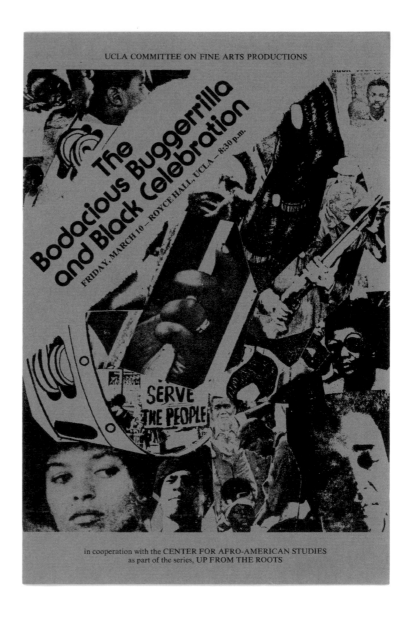

(above left)
Untitled (Bodacious
Buggerrilla performance still)
c. 1968–1975
Archival digital print
11 × 14 in.
Courtesy of the artist

(above right)
Untitled (Bodacious
Buggerrilla practice and
brainstorming session for
Jesus Scene)
c. 1968–1975
Archival digital print
11 × 14 in.
Courtesy of the artist

(bottom)
Untitled (Bodacious
Buggerrilla pamphlet)
c. 1968–1975
Ink on paper
9 × 6 in.
Courtesy of the artist

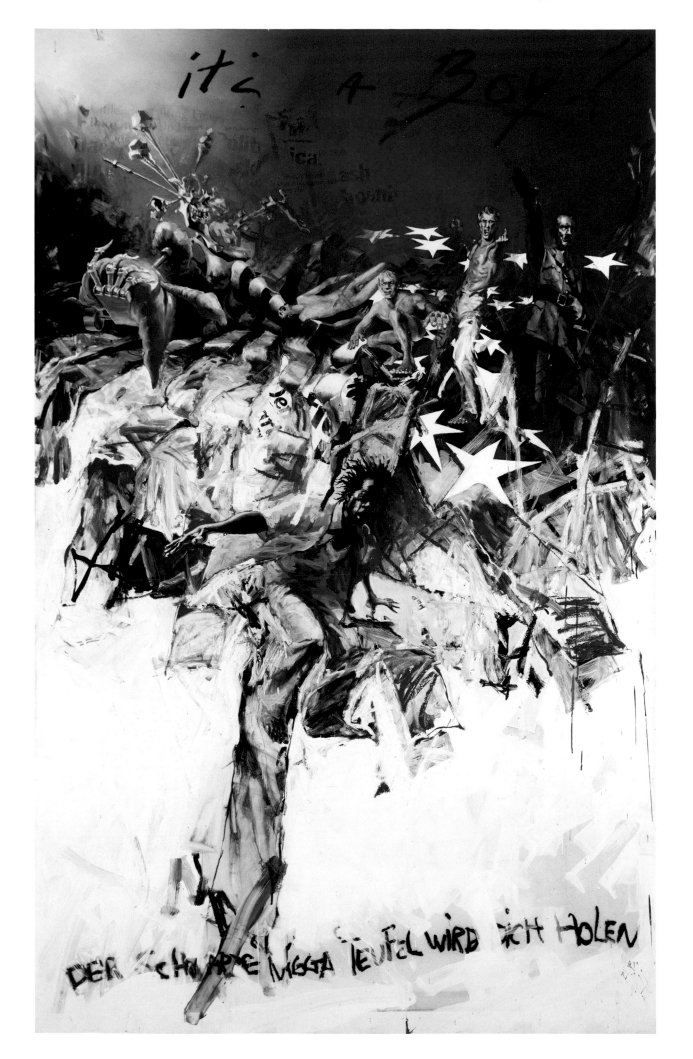

ED BEREAL: THE BELLINGHAM PERIOD

Vernon Damani Johnson

When asked by the artist himself to contribute to the catalogue for *Wanted: Ed Bereal for Disturbing the Peace*, I was truly honored. Although we grew up almost a continent apart, he is like the big brother I never had in the mean streets of Cincinnati, Ohio, in the mid-twentieth century. All those miles apart, we came to our intellectual and political maturities in the tumultuous 1960s: Bereal, after hobnobbing with the elites in the Los Angeles art scene, and I, when aspiring to go to Vietnam and drop napalm on the natives in the name of liberty. Black rebellions in Watts, Los Angeles, and Avondale, Cincinnati, shocked us into reversing our paths. I think it is the recognition of the value of "shock therapy" that motivates much of Bereal's later work. I am honored to share my reflections on the political content of his work, with special attention to the Bellingham period of his career.

I met Ed Bereal when he interviewed for a tenure track position in the Art Department at Western Washington University over the winter of 1993. Though I couldn't comment on the details of the work he shared that day, I recall being taken by the way his art was laced with social and political commentary. We chatted briefly after his talk and I gave him my business card and told him to get in contact with me if he got the job.

Bereal got the job, and not long after he moved to Bellingham, my wife Rebecca and I were invited to his home and he walked us through his studio. I was fascinated by the way he excavated the unsettling side of Norman Rockwell and Miss America. By the time Bereal settled in Bellingham, he was done with Rockwell. But as noted by Amy Chaloupka in the introductory essay of this catalogue, Bereal saw in Rockwell's painting what was so revered in Ernest Hemingway's writing: the quintessential twentieth-century white American male perspective. Miss America covers that ground and offers so much more regarding the themes that Bereal wished to undertake more fully, and which he would have the time to explore in his Bellingham period. In 1967 Martin Luther King Jr. had expanded his political agenda, calling upon us to address the three evils of racism, poverty, and militarism. His targeting of militarism called attention to America's role in the global arena.[1] In a similar vein and around the same time, beginning with his assemblage *America: A Mercy Killing*, Bereal began to weave forces of "class, race, media, government, and corporate power" into a complex narrative reflecting the way the world looked from where he sat.[2] By the turn of the century his work was consistently taking on the mélange of racism, capitalist consumerism, and American imperialism (figs. 1 and 2).

Miss America, the fairest damsel in the land, surrounded by the Stars and Stripes, would return again

Fig. 1
The Birthing of the American Middle Class
1999
Oil on composite material
80 × 50 in.
Courtesy of the artist
Photo: Courtesy of David Scherrer

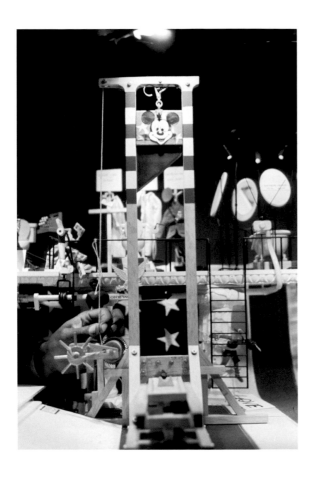

and again and with ever more force and urgency. Miss America: the beauty on whose behalf "men" would go to the ends of the earth and commit wholesale slaughter to defend. Bereal's Miss America is not beautiful, however. She is a skeleton made of steel, her crown a series of nails driven into her skull. Bereal forces us to think about the real place, in terms of our humanity, that the American ideal represents for those on the margins in the artist's home country as well as for peoples around the globe.

Bereal's earliest piece in the show from the Bellingham period is *Homage to LA: Just a Lil' Sumpthin for the Kids* (fig. 3). It seems to be a farewell to his days in Southern California, the land of sunshine, but also of police brutality and the Crips and the Bloods. We see Miss America, skeletal and mechanical as ever, astride the American flag, depicting the spiritual death bound up in our consumerism, as she shops for toys "for the kids." Amongst the "toys" in the cart we find two handguns, important elements in the violence that's always been central to the achievement of the American Dream and its sustenance in future generations. He returns to these themes in *Military/Business + God = War + Kids* (fig. 4). We see three children—two white and one "pickaninny"—reaching for a handgun being extended by a businessman. The names of popular video games (which offer many violent options) in the background suggest the gun as a toy. The gun seems to be in closer reach for the white kids than for the Black child. Isn't that the way it always is, or at least needs to be, for white America to feel safe? The businessman and the video game logos against the backdrop of the American flag tell us that violence is as American as apple pie and that our young must continue to be socialized favorably toward it.

Most compelling is a series of works where Bereal grapples with the impacts of the presidency of George W. Bush. Starting with *Again (Miss America, George Dubya and the Missing Florida Votes)*,

Fig. 2 (see pp. 34–35 for complete image)
America: A Mercy Killing, detail
1966-1974
Mixed media kinetic sculpture
27¼ × 55½ × 45 in.
Smithsonian American Art Museum, Museum purchase
Photo: Courtesy of the artist

Fig. 3 (opposite page)
Homage to LA: Just a Lil' Sumpthin for the Kids
1994
Mixed media and found object
84 × 63 × 32 in.
Courtesy of the artist
Photo: Courtesy of Harmony Murphy Gallery, Los Angeles

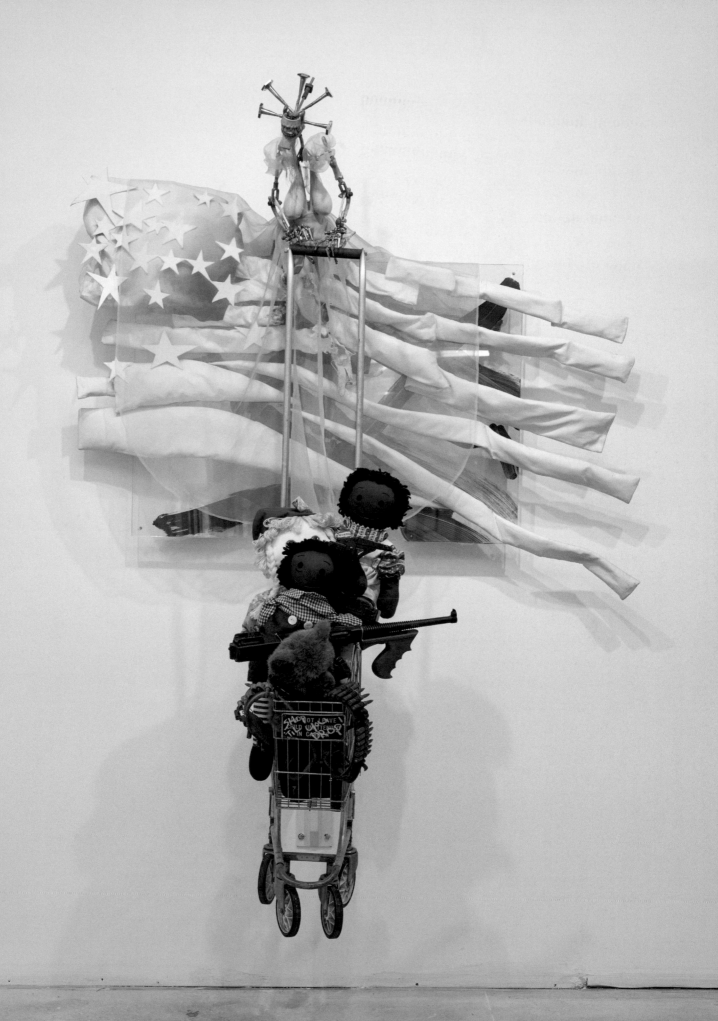

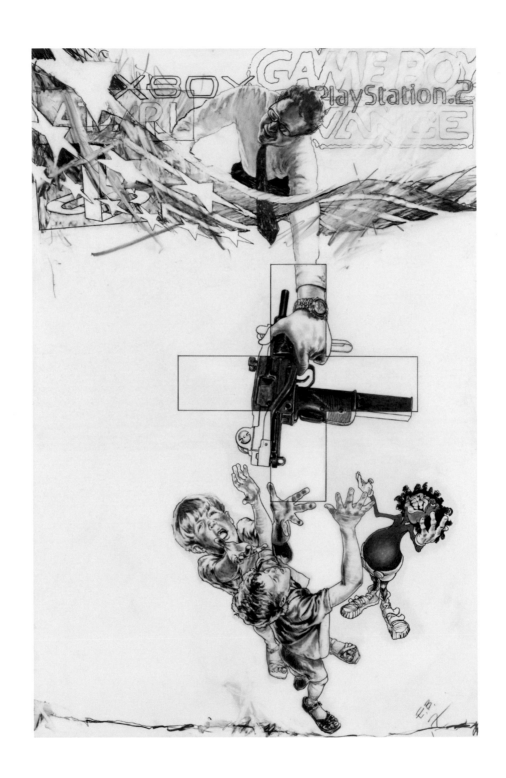

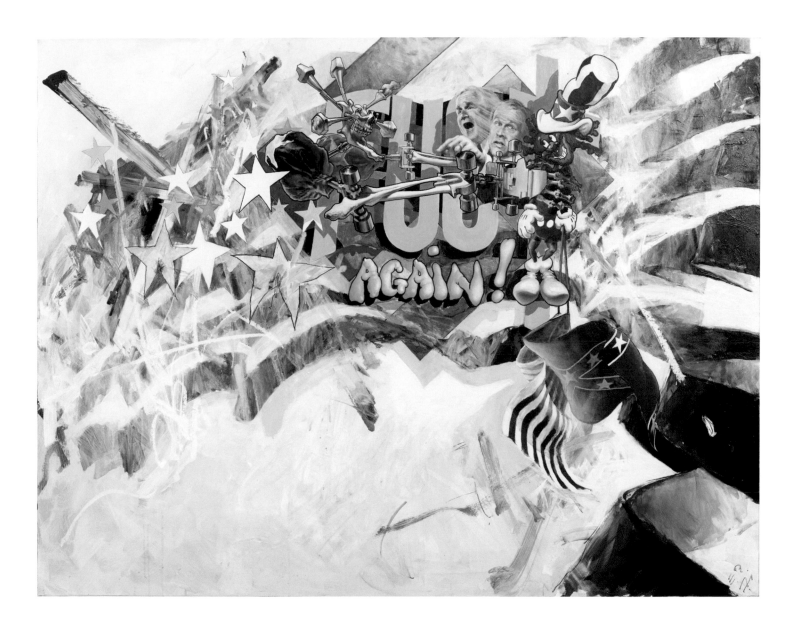

Fig. 4 (opposite page)
*Military/Business + God =
War + Kids*
2003
Graphite on paper
36⅜ × 24½ in.
Collection of Casey Kaufman
Photo: Courtesy of Harmony
Murphy Gallery, Los Angeles

Fig. 5
*Again (Miss America, George
Dubya and the Missing Florida
Votes)*
2002
Oil on composite material
38½ × 49¾ in.
Courtesy of the artist
Photo: Courtesy of Harmony
Murphy Gallery, Los Angeles

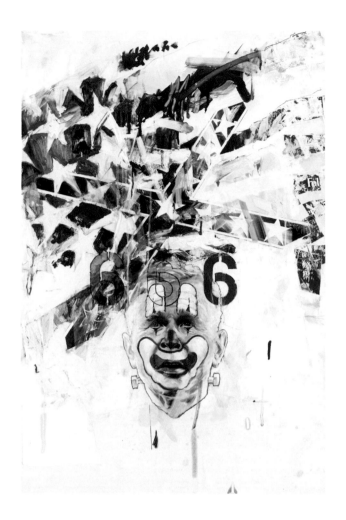

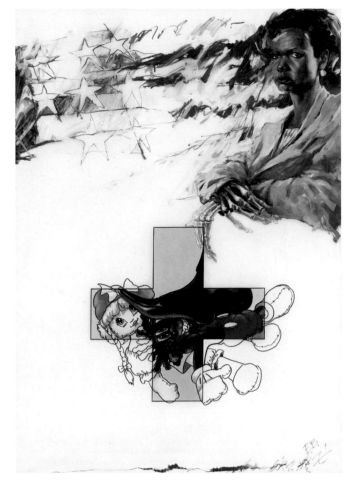

we see the intersecting social forces that are the staple of his work (fig. 5). Miss America orchestrates everything. When we recall the questionable voting processes which handed the election to Bush, and African American votes being disqualified, we find Bush himself confused because he expected an easier time in the state that his brother governed. And we find an even more confused African American voter, again represented by the pickaninny, this time dressed as Mickey Mouse, holding both the American and Confederate flags. Bereal often uses the flags together to suggest that they share a great deal of common ground regarding their defense of white supremacy. The expletive partially covered, and perhaps ebonicized, seems to sum things up nicely.[3]

September 11 and the American invasion of the Islamic world provide the template for Bereal to display the full weight of his intellectual powers. In 2003, the year of the ill-fated Iraq invasion, there is *America's Self-Portrait: Three Schmucks & We're Out* (fig. 6). Here we witness George W. Bush in clown face, with screws in his neck. In the background we again have both the Stars and Stripes, and the Stars and Bars, and overlaying it all is the satanic symbol "666." A year later we have *Mona Lisa/Condoleezza, Angel of Darkness* (fig. 7). Condoleezza Rice, the first African American woman to serve as US Secretary of State, under Bush, is depicted as placid as the Italian icon (though perhaps not, as the look around her eyes betray a steeliness we don't see in her counterpart). Her heel is in the throat of the pickaninny displayed atop the Christian cross. Beneath the entire image is a blond-haired doll, which also appeared in *Homage to LA.* In both instances the juxtaposition of the innocence of childhood, protected or

Fig. 6 (above left)
America's Self-Portrait; Three Schmucks & We're Out
2003
Oil on composite material
34¾ × 23 in.
Courtesy of the artist
Photo: Courtesy of Harmony Murphy Gallery, Los Angeles

Fig. 7 (above right)
Mona Lisa/Condoleezza, Angel of Darkness
2004
Oil on composite material
41¼ × 29 in.
Courtesy of the artist
Photo: Courtesy of Harmony Murphy Gallery, Los Angeles

Fig. 8 (opposite page)
Location, Location, Location (Iraq/Afghanistan)
2006
Oil on composite material
73 × 42½ in.
Courtesy of the artist
Photo: Courtesy of Harmony Murphy Gallery, Los Angeles

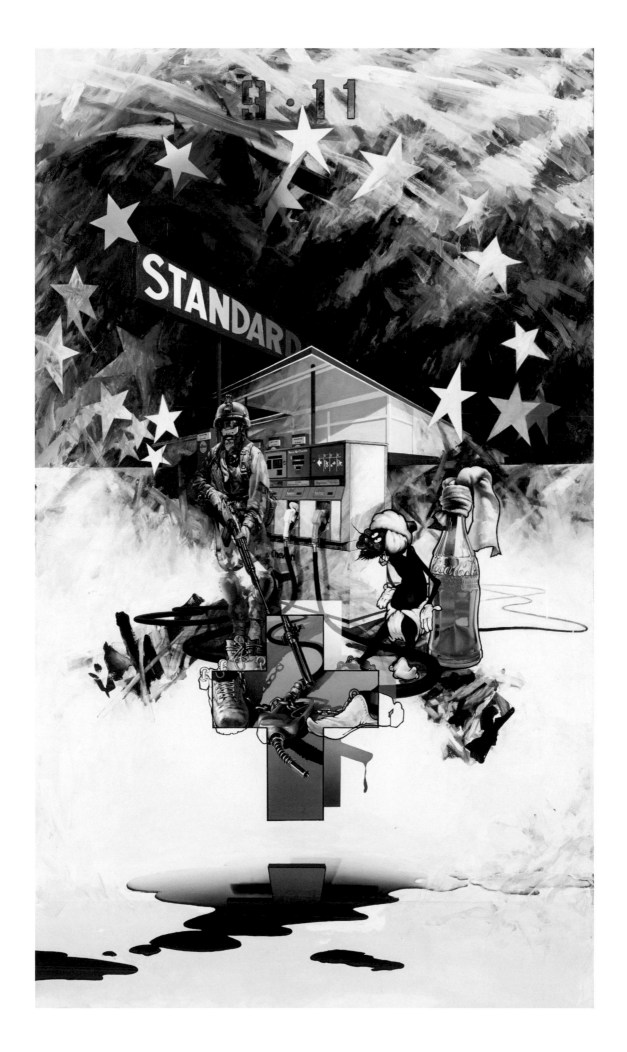

Fig. 9 (opposite page)
Miss America Presents Domestic Terrorism
2003/2015
Graphite on paper
48 × 45 in.
Courtesy of the artist
Photo: Courtesy of Harmony Murphy Gallery, Los Angeles

(above)
Untitled (preparatory sketch)
c. 1989
Graphite on vellum
14 × 19 in.
Courtesy of the artist

destroyed—depending on your perspective—by adult violence, is stark. Finally, after nearly five years of war in Afghanistan and three in Iraq, there is the no-holds-barred *Location, Location, Location* (fig. 8). This painting is a devastating critique of US imperialism across the Islamic world, especially in Iraq, which held the world's fifth-largest petroleum reserves during the first decade of this century. The association of American corporate greed with a militaristic imperialism in the name of God are all there to see. And then there is the poor, turbaned Iraqi, replacing the pickaninny and fighting for his sovereignty but having to use a Molotov cocktail made from a corporate American Coca Cola bottle. The long and tragic American intervention offers rich terrain for Bereal to fully tease out the interplay of social forces he had been thinking about for decades.

The show also includes two pieces that germinated for Bereal over a period of more than a decade. *Miss America: Manufacturing Consent: Upside Down and Backwards* features some typical Bereal imagery: Miss America wrapped in the flag, hammering her propaganda into the upside down and backward head of a white businessman (see page 42). It speaks for itself. More interesting for me is *Miss America Presents Domestic Terrorism,* in which Bereal returns to his longstanding concerns over race and police brutality at home (fig. 9). The piece is captioned with "Miss America Presents: New York's Finest." Bereal was probably reminded of (incidents from) the still-prevalent fallout over the NYPD killing of unarmed Guinean immigrant Amadou Diallo in 1999 through the killing of unarmed Sean Bell on his wedding day in 2006 (with numerous other heavy-handed incidents occurring in between—broken windows policing!).[4] But faded in the backdrop we see the collaged headline "The death of Freddie Gray" recalling the

young Black man in Baltimore who was picked up for loitering on the street in the early morning, placed in a paddy wagon, and dead with a broken neck by the time he arrived at the police station. That incident happened in early 2015, after a string of high-profile police killings of unarmed Black men in several cities across the country beginning in the summer of 2014, which gave rise to the Black Lives Matter movement. A defiant cop is there in the foreground and he is buttressed by the ever-present Miss America and that indomitable flag.

It is fitting that we've come full circle from the post–Watts Rebellion Days of the mid-1960s to the present in Bereal's work. He remains unyielding in his critique, and one might well come away from the show depressed over the prospects for our nation and the world. That would be a shame! By portraying the awful way that our "systems" compel some people to treat other people, Bereal is assuming that we are indeed moral beings, and that most of us do not wish to participate consciously in such immoral systems. What my generation referred to as "social consciousness" the millennials call being "woke." The question left for anyone viewing this retrospective of Ed Bereal's work: If you're woke, what are you going to do?

NOTES

1 Martin Luther King Jr., "A Time to Break the Silence" (speech delivered at Riverside Church, New York City, April 4, 1967), in I Have a Dream: Writings and Speeches that Changed the World, ed. James M. Washington (San Francisco: Harper Collins, 1992), 135–52.

2 See Amy Chaloupka, "Disturbing the Peace" in this publication.

3 Ebonicized refers to ebony phonics, or ebonics, a term linguistics scholars use to refer to African American Vernacular English.

4 Broken windows policing theory holds that maintaining order by policing low-level offenses can prevent more serious crimes. It involves aggressive police action toward neighborhood residents and has been controversial in minority urban neighborhoods. See Sarah Childress, "The Problem with Broken Windows Policing," Frontline, PBS, June 28, 2016, https://www.pbs.org/wgbh/frontline/article/the-problem-with-broken-windows-policing/.

Untitled (preparatory sketch)
c. 1999
Graphite on vellum
22½ × 14¾ in.
Courtesy of the artist

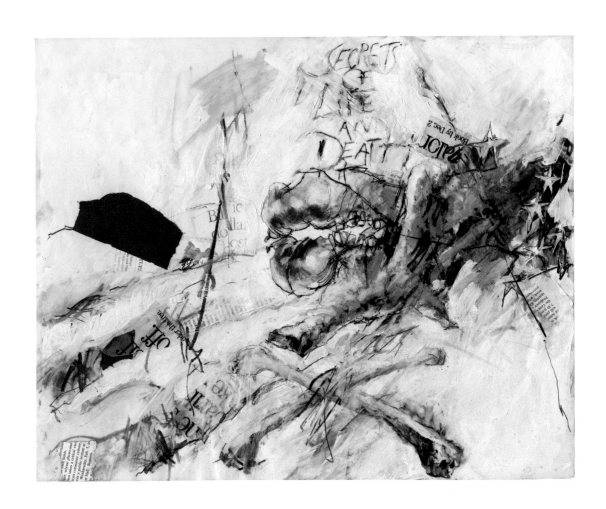

(above)
Untitled (preparatory sketch)
c. 1989
Oil and mixed media on board
14 × 17 in.
Courtesy of the artist

(opposite page)
*Miss America Preparing John
Doe for Public Service*
c. 2002–2003
Oil on composite material
96 × 50 in.
Courtesy of the artist

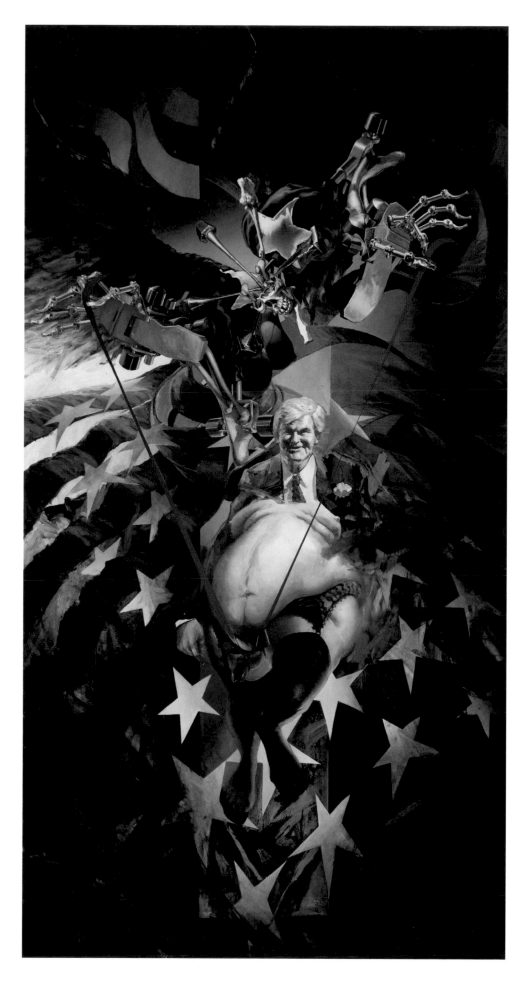

b. 1937 Los Angeles, California
Lives and works in Bellingham, Washington

EDUCATION

Chouinard Art Institute, 1958–1962

Private study under artists:
John Chamberlain, Sculpture, 1966–1968
John Altoon, Painting and Drawing, 1965–1967
Peter Voulkos, Sculpture, 1962–1964

SELECTED EXHIBITIONS

2019
Wanted: Ed Bereal for Disturbing the Peace,
Retrospective, Whatcom Museum, Bellingham,
Washington

2018
First Glimpse: Introducing The Buck Collection,
The UCI Institute and Museum for California Art,
Irvine, California

2016
Disturbing the Peace, Solo exhibition, Harmony
Murphy Gallery, Los Angeles

2011
Pacific Standard Time, J. Paul Getty Museum,
Los Angeles

*Best Kept Secret: UCI and the Development
of Contemporary Art in Southern California
1964–1971*, Laguna Art Museum, Laguna Beach,
California

Self-Portrait, from S.M.S. No. 6
1968
Offset lithograph
16⅛ × 13½ in.
Courtesy of the artist

2010
L.A. Rising: SoCal Artists Before 1980, Publication
only, California/International Arts Foundation,
Los Angeles

2009
*Hot Spots: Rio de Janeiro / Milano - Torino /
Los Angeles*, Kunsthaus, Zurich, Switzerland

2008
Time & Place: Los Angeles 1957–1968, Moderna
Museet, Stockholm, Sweden

*Voices of Dissonance: A Survey of Political Art
1930–2008*, ACA Galleries, New York

2007
*LA Object and David Hammons Body
Prints*, Roberts & Tilton Gallery, Los Angeles

The Cool School, Documentary,
Filmmaker Morgan Neville, Ferus Gallery,
Los Angeles

Ship of Fools, Blue Horse Gallery, Bellingham,
Washington

2006
LA Object and David Hammons Body Prints, Jack
Tilton Gallery, New York

Paris-Los Angeles 1955–1985, Centre Georges
Pompidou National Museum of Modern Art, Paris

Ship of Fools, Blue Horse Gallery, Bellingham,
Washington

2005
Political Images, Mt. Hood Community College,
Portland, Oregon

Ship of Fools, Blue Horse Gallery, Bellingham,
Washington

2004
D.C. Comics, Solo exhibition, Elizabeth Leach Gallery, Portland, Oregon

2003
Faculty Exhibition, The Western Gallery, Western Washington University, Bellingham, Washington

Ship of Fools, Blue Horse Gallery, Bellingham Washington

2002
Disturbing the Peace, Solo exhibition, Elizabeth Leach Gallery, Portland, Oregon

2001
Chouinard: A Living Legacy, Oceanside Museum of Art, Oceanside, California

2000
Faculty Exhibition, Whatcom Museum of History and Art, Bellingham, Washington

1999
Crisis in Kosovo, Pontifex Media Center, Savannah, Georgia, and the Whatcom Museum of History and Art, Bellingham, Washington

1998
Miniature Show, History of the World Gallery, Camano Island, Washington

Works on Paper, Elizabeth Leach Gallery, Portland, Oregon

Faculty Exhibition, The Western Gallery, Western Washington University, Bellingham, Washington

1997
Elusive Paradise: Los Angeles Art from the Permanent Collection, Museum of Contemporary Art, Los Angeles

National Black Fine Art Exhibition, Porter Troupe Gallery, New York

1996
Honey, I Shrunk the Art, History of the World Gallery, Camano Island, Washington

Open Your Heart, Leo Castelli Gallery, New York

1995
Faculty Exhibition, The Western Gallery, Western Washington University, Bellingham, Washington

1994
Select Works from Havana, The Ludwig Forum for International Art, Aachen, Germany

14 Northwest Artists, History of the World Gallery, Camano Island, Washington

The 5th International Biennial, The Centro Wilfredo Lam, Havana, Cuba

1993
Faculty Exhibition, The Western Gallery, Western Washington University, Bellingham, Washington

PERFORMANCE, PRESENTATIONS, AND PROFESSIONAL AFFILIATIONS

2016
Panelist, *On Politics and Performance,* with Jerri Allyn, Nancy Buchanan, Carolina Caycedo, Patrisse Kahn-Cullors, and Harry Gamboa Jr., The Main Museum, Los Angeles

2012
Panelist, *Assemblage and Politics*, with Mel Edwards, George Herms, Nancy Reddin Kienholz, and Betye Saar, Getty Research Institute, Los Angeles

Participant, Conversation and performance, The *Bodacious Buggerrilla,* with Larry Broussard, Bobby Farlice, DaShell Hart, Tendai Jordan, Barbara Lewis, and Alyce Smith-Cooper, moderated by Malik Gaines, Getty Center, Los Angeles

1998
Panelist, *Power to the People: L.A. From the Late '60s Through the '70s,* with John Baldessari, Rosamund Felsen, Harry Gamboa Jr., Peter Plagens, and Miriam Shapiro, moderated by Hunter Drohojowska-Philp, UCLA, Los Angeles

1996–1997
Artist in Residence, Portlaoise Prison, Video production assistance to residents, County Laois, Ireland

1991–1993
Cinematographer, Documentation of cultural and political figures worldwide, Pontifex Media Center, Middle East

1988–1993
Cinematographer, Scientific expedition in Soviet Union, NHK Japan Broadcast Corporation, Tokyo

1976–1994
Artistic director, Bodacious TV Works, including the production of game show *Pull Your Coat* (1986), Los Angeles

1976
Founder, Bodacious TV Works, a film production company, Los Angeles

1970
Performer, "Man, Machine & Race," for *Experiments in Art and Technology, In Process,* Conference, Getty Research Institute, Los Angles

1968
Founder, Bodacious Buggerilla, political street theater troupe, Riverside, California

Participant, Watts Writers Workshop, Los Angeles

(opposite page)
Untitled (Ed Bereal and NASA Scientist Chris Chyba in Siberia)
1991
Photo: Courtesy of the artist

Untitled (*Wanted* poster)
1985
Ink on paper
24 × 17 in.
Courtesy of the artist

Mr. President
c. 1960
Ink on paper
2½ × 6⅛ in.
Courtesy of the Estate of
Ron Miyashiro

AWARDS AND ACADEMIC HONORS

2002
Research Grant, Western Washington University

1994
Research Grant, Western Washington University

1985
National Endowment for the Arts, Expansion Arts Grant (media)

1984
University of California Research Grant

1982
American Film Festival Award

1979
Candidate, Rockefeller Foundation Award

1975 –1984
National Endowment for the Arts, Expansion Arts Program

1969
Janss Foundation Award

1966
Copley Foundation Award

ACADEMIC APPOINTMENTS

1993 – 2007
Associate Professor, Western Washington University, Bellingham
College of Fine and Performing Arts: Department of Art

1968 –1993
Senior Lecturer, Tenured, University of California, Irvine
Department of Art: Drawing, Painting, Video Production, Graduate Studies

1991–1993
Visiting Scholar, Santa Monica School of Art and Architecture
Instructor in Painting, Drawing, and Video

1968 –1971
Visiting Scholar, University of California, Riverside
Instructor of Black Studies in Art

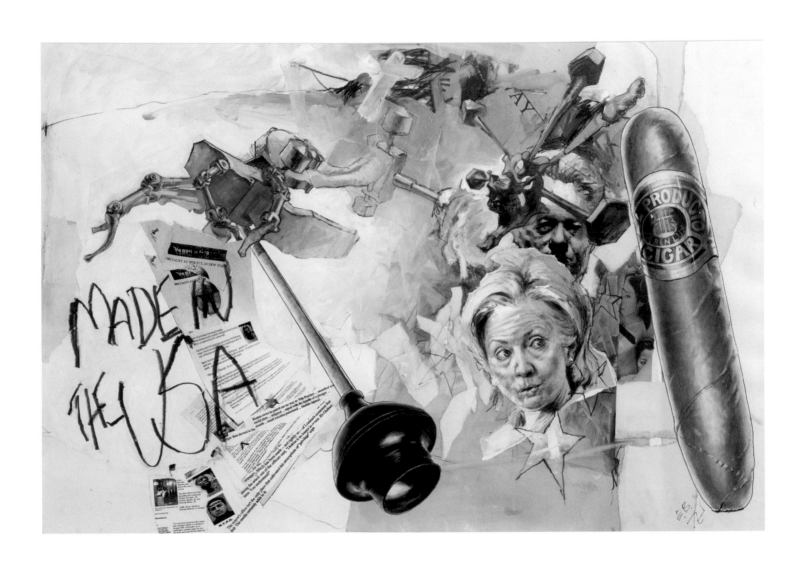

*El Producto, a Plumber's
Friend*
2002
Graphite and mixed media on
paper
27 × 40 in.
Collection of Kay Sardo

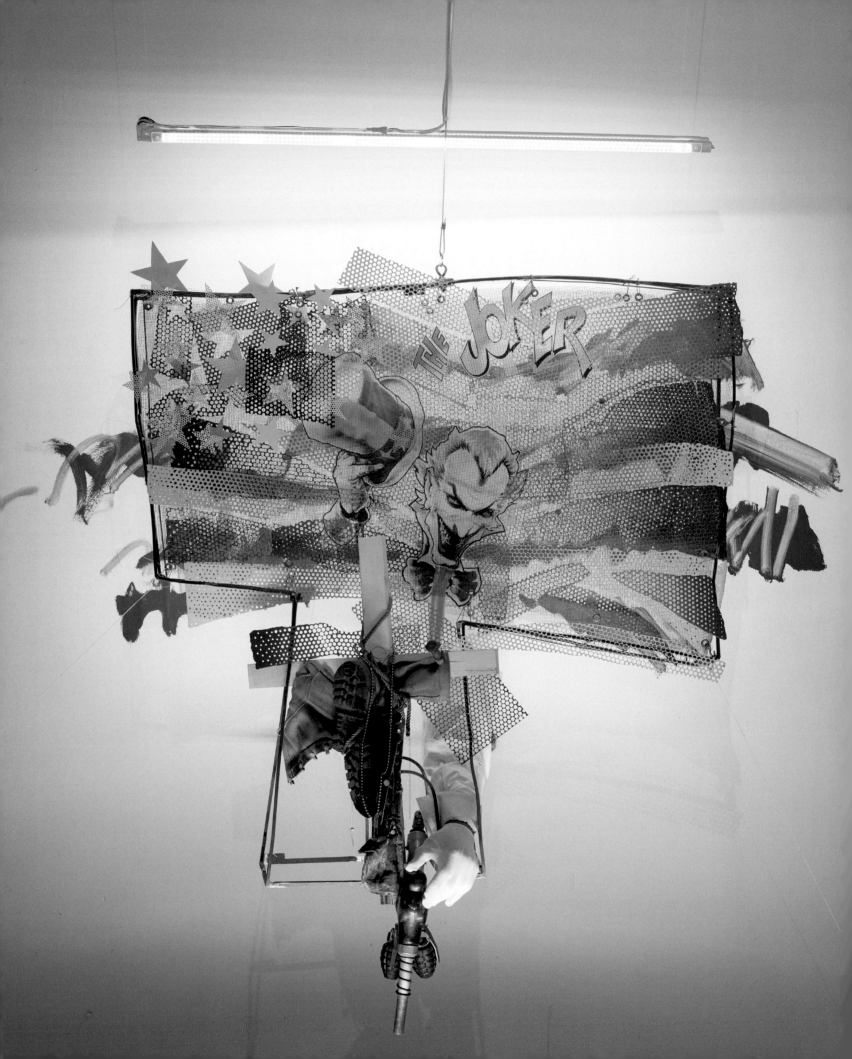

All works by Ed Bereal unless otherwise noted

Height precedes width precedes depth

Objects with asterisk (*) denote works represented only in the publication

Photographer unknown
* Untitled (family archive image)
c. 1930s
Silver gelatin print
7 × 9 in.
Courtesy of the artist

*Untitled
c. 1958
Paint on board
14 × 16 in.
Courtesy of the artist

*Untitled
c. 1958
Paint on board
16½ × 22¼ in.
Courtesy of the artist

Giant Steps
1958
Oil on sculpted canvas
20 × 20 × 6 in.
Collection of Allan and Luwana Bereal

Fokker - D7
1958
Stretched canvas with mixed media
14 × 12½ × 5 in.
Collection of the Fillmore Family

Summer Mechanic
1958–1959
Stretched canvas with mixed media
9 × 6 × 4½ in.
Courtesy of Tilton Gallery, New York

Untitled (sketchbook)
c. 1958–1965
Graphite on paper
11 × 8½ × ½ in.
Courtesy of the artist

Untitled (sketchbook)
c. 1958–1965
Graphite on paper
11 × 8½ × ½ in.
Courtesy of the artist

Joker
2011
Mixed media and found objects
49 × 64 × 16 in.
Courtesy of the artist
Photo: Courtesy of Harmony Murphy Gallery, Los Angeles

Untitled (self-portrait)
c. 1958–1965
Graphite on paper
11 × 8½ in.
Courtesy of the artist

Untitled (self-portrait)
c. 1958–1965
Graphite on paper
11 × 8½ in.
Courtesy of the artist

Untitled (self-portrait)
c. 1958–1965
Graphite on paper
11 × 8½ in.
Courtesy of the artist

Untitled (self-portrait)
c. 1958–1965
Graphite on paper
11 × 8½ in.
Courtesy of the artist

Untitled (self-portrait)
c. 1958–1965
Graphite on paper
11 × 8½ in.
Courtesy of the artist

Untitled (self-portrait)
c. 1958–1965
Graphite on paper
11 × 8½ in.
Courtesy of the artist

Untitled (self-portrait)
c. 1958–1965
Graphite on paper
11 × 8½ in.
Courtesy of the artist

Untitled
c. 1958–1965
Graphite and paint on paper
11 × 8½ in.
Courtesy of the artist

Untitled
c. 1958–1965
Graphite and paint on paper
11 × 8½ in.
Courtesy of the artist

Untitled
c. 1958–1965
Graphite and paint on paper
11 × 8½ in.
Courtesy of the artist

Untitled
c. 1958–1965
Graphite and paint on paper
11 × 8½ in.
Courtesy of the artist

Untitled
c. 1958–1965
Graphite and paint on paper
11 × 8½ in.
Courtesy of the artist

Untitled
c. 1958–1965
Graphite on paper
11 × 8½ in.
Courtesy of the artist

Untitled
c. 1958–1965
Graphite on paper
11 × 8½ in.
Courtesy of the artist

Untitled
c. 1958–1965
Graphite on paper
11 × 8½ in.
Courtesy of the artist

Untitled
c. 1958–1965
Asphalt on paper
15 × 11½ in.
Courtesy of the artist

Untitled
c. 1958–1965
Asphalt on paper
15 × 11½ in.
Courtesy of the artist

Untitled
c. 1958–1965
Asphalt on paper
11 × 8½ in.
Collection of Leslie Jacobson
Photo: Courtesy of David Scherrer

Untitled
c. 1958–1965
Graphite on paper
12 × 9¾ in.
Collection of Leslie Jacobson
Photo: Courtesy of David Scherrer

Untitled
c. 1958–1965
Graphite on paper
12 × 9 ½ in.
Courtesy of the artist

Untitled
c. 1958–1965
Collage and mixed media on board
12 × 10 in.
Courtesy of the artist

Untitled
c. 1958–1965
Collage and mixed media on board
12½ × 8½ in.
Courtesy of the artist

Untitled
c. 1958–1965
Collage and paint on board
12½ × 10 in.
Courtesy of the artist

Untitled
c. 1958–1965
Collage and paint on board
12½ × 10 in.
Courtesy of the artist

Blohm und Voss P210
1960
Stretched canvas with mixed media
and found objects
8¾ × 8 × 2 in.
Courtesy of Tilton Gallery, New York

Focke-Wulf FW 190
1960
Mixed media
21¼ × 12 × 6 in.
The Buck Collection at the UCI
Institute and Museum for California Art
© 2018 The Regents of The University
of California

* Mr. President
c. 1960
Ink on paper
2½ × 6⅛ in.
Courtesy of the Estate of Ron
Miyashiro

* Junker Ju
1960–1961
Oil paint, leather, nails, and metal pipes
16 × 8 × 3 in.
Whereabouts unknown
Photo: Courtesy of Laguna Art
Museum, Laguna Beach, California

Jerry McMillan
Untitled (Ed Bereal Seated in Studio,
Los Angeles)
c. 1961–1964
Silver gelatin print
14 × 11 in.
Courtesy of the artist
Photo: Jerry McMillan, Courtesy of
Craig Krull Gallery, Santa Monica,
California

Jerry McMillan
Poster, War Babies Exhibition at
Huysman Gallery, Los Angeles
May 29–June 17, 1961
21⅞ × 17 in.
Courtesy of the artist
Photo: Jerry McMillan, Courtesy of
Craig Krull Gallery, Santa Monica,
California

*Jerry McMillan
Untitled (Ed Bereal Seated in Studio,
Los Angeles)
c. 1961–1964
Silver gelatin print
14 × 11 in.
Courtesy of the artist
Photo: Jerry McMillan, Courtesy of
Craig Krull Gallery, Santa Monica,
California

Untitled
1961
Mixed media and pigment on paper
9¾ × 13½ in.
Collection of Chuck and Dee Robinson

Untitled
c. 1961–1962
Mixed media on paper
14 × 8½ in.
Collection of Gordon and Robin Plume

Untitled
c. 1961–1962
Mixed media on paper
14 × 8½ in.
Collection of Gordon and Robin Plume

Nautilus
1962
Stretched canvas with mixed media
6 × 12½ × 4 in.
Collection of Nancy Kienholz

*Stuka Ju 87
1962
Stretched canvas with mixed media
and found objects
14 × 11½ × 2 in.
Whereabouts unknown
Photo: Courtesy of the artist

Untitled (self-portrait)
c. 1962–1965
Graphite on paper
11 × 8½ in.
Courtesy of the artist

Untitled
c. 1962–1965
Graphite on paper
8½ × 11 in.
Courtesy of the artist

Untitled
c. 1962–1965
Graphite on paper
11 × 8½ in.
Courtesy of the artist

Untitled (preparatory drawing)
c. 1962–1965
Graphite on paper
11 × 8½ in.
Courtesy of the artist

Untitled (preparatory drawing)
c. 1962–1965
Graphite on paper
11 × 8½ in.
Courtesy of the artist

Untitled (preparatory drawing)
c. 1962–1965
Graphite on paper
11 × 8½ in.
Courtesy of the artist

Untitled (preparatory drawing)
c. 1962–1965
Graphite on paper
11 × 8½ in.
Courtesy of the artist

Artist: Immortal Beloved
1962/2015
Mixed media
34½ × 18⅜ × 8 in.
Courtesy of the artist
Photo: Courtesy of Harmony Murphy
Gallery, Los Angeles

Untitled
c. 1963
Graphite and mixed media on paper
16 × 12 in.
Collection of Kay Sardo

Untitled
1963
Mixed media on paper
11 × 8½ in.
Collection of Chuck and Dee Robinson

Untitled
1964
Mixed media on paper
11 × 8 in.
Collection of Jane and Robert
Sylvester

* Marvin Silver
Untitled photograph (Ed Bereal in
spray booth)
c. 1965
Silver gelatin print
14 × 11 in.
Photo: Courtesy of Marvin Silver

Untitled (preparatory drawing)
c.1965
Graphite on paper
11 × 8½ in.
Courtesy of the artist

American Beauty
1965
Mixed media
53 × 36 × 14 in.
The Buck Collection at the UCI
Institute and Museum for California Art
© 2018 The Regents of The University
of California

Untitled
1966
Graphite on paper
11 × 8½ in.
Courtesy of the artist

Untitled
1966
Graphite on paper
11 × 8½ in.
Courtesy of the artist

Untitled
1966
Graphite on paper
11 × 8½ in.
Courtesy of the artist

America: A Mercy Killing
1966–1974
Mixed media kinetic sculpture
27¼ × 55½ × 45 in.
Smithsonian American Art Museum,
Museum purchase

Untitled
1967
Ink on paper
11¾ × 8¾ in.
Courtesy of the artist

Untitled
1967
Ink on paper
11¾ × 8¾ in.
Collection of Ken Hanna

Untitled
1967
Ink on paper
11¾ × 8¾ in.
Courtesy of the artist

Untitled
1968
Mixed media on paper
16 × 12 in.
Courtesy of the artist

Untitled
1968
Mixed media on paper
16 × 12 in.
Courtesy of the artist

Untitled
c. 1968
Mixed media on paper
10¾ x 8¼ in.
Courtesy of the artist

Untitled
c. 1968
Mixed media on paper
10¾ x 8 ¼ in.
Courtesy of the artist

Untitled
c. 1968
Mixed media on paper
9 x 11¾ in.
Courtesy of the artist

Self-Portrait, from S.M.S. No. 6
1968
Offset lithograph
16⅛ × 13½ in.
Courtesy of the artist

Untitled (Freedom Draft Movement
poster)
c. 1968
Ink on paper
22 × 17 in.
Courtesy of the artist

Untitled (Bodacious Buggerrilla
performance still, Ed Bereal as
Uncle Sam)
c. 1968–1975
Archival digital print
14 × 11 in.
Courtesy of the artist

Untitled (Bodacious Buggerrilla
performance still from *Bus Stop*)
c. 1968–1975
Archival digital print
11 × 14 in.
Courtesy of the artist

Untitled (Bodacious Buggerrilla
performance still)
c. 1968–1975
Archival digital print
11 × 14 in.
Courtesy of the artist

Untitled (Bodacious Buggerrilla
performance still)
c. 1968–1975
Archival digital print
11 × 14 in.
Courtesy of the artist

Untitled (Bodacious Buggerrilla
performance still)
c. 1968–1975
Archival digital print
11 × 14 in.
Courtesy of the artist

Untitled (Bodacious Buggerrilla
performance still from *Temptations of
Uncle Sam*)
c. 1968–1975
Archival digital print
11 × 14 in.
Courtesy of the artist

Untitled (Bodacious Buggerrilla group
photograph)
c. 1968–1975
Archival digital print
11 × 14 in.
Courtesy of the artist

Untitled (Bodacious Buggerrilla
performance at University of California,
Riverside)
c. 1968–1975
Archival digital print
11 × 14 in.
Courtesy of the artist

Untitled (Bodacious Buggerrilla
performance at University of California,
Riverside)
c. 1968–1975
Archival digital print
11 × 14 in.
Courtesy of the artist

Untitled (Bodacious Buggerrilla
performance still from *Killer Joe*)
c. 1968–1975
Archival digital print
14 × 11 in.
Courtesy of the artist

Untitled (Bodacious Buggerrilla
publicity shot, Venice Jail)
c. 1968–1975
Archival digital print
11 × 14 in.
Courtesy of the artist

Untitled (Bodacious Buggerrilla
practice and brainstorming session for
Jesus Scene)
c. 1968–1975
Archival digital print
11 × 14 in.
Courtesy of the artist

Untitled (Bodacious Buggerrilla
pamphlet)
c. 1968–1975
ink on paper
9 × 6 in.
Courtesy of the artist

* Untitled (Bodacious Buggerrilla
 promotional poster)
c. 1968–1975
Ink on paper
20 × 18 in.
Courtesy of the artist

* Untitled (Ed Bereal seated with
 students, University of California, Irvine)
c. 1970
Silver gelatin print
5 × 7 in.
Courtesy of the artist

* *Recipe for the System's Pie*
c. 1972
Printed graphic and text
Courtesy of the artist

Ronnie's Purse
1980
Mixed media, found objects
44 × 11½ × 6½ in.
Courtesy of the Estate of Ron Miyashiro
Photo: Courtesy of David Scherrer

* Untitled (Wanted poster)
1985
Ink on paper
24 × 17 in.
Courtesy of the artist

Untitled (*Pull Your Coat* production still)
1986
Archival digital print
11 × 14 in.
Courtesy of the artist

Untitled (*Pull Your Coat* production still)
1986
Archival digital print
11 × 14 in.
Courtesy of the artist

Untitled (*Pull Your Coat* production still)
1986
Archival digital print
11 × 14 in.
Courtesy of the artist

Untitled (*Pull Your Coat* production still)
1986
Archival digital print
14 × 11 in.
Courtesy of the artist

* Untitled (*Pull Your Coat* film still)
1986
Video with sound: approx. 27 min.
Courtesy of the artist

* Untitled (*Pull Your Coat* film still)
1986
Video with sound: approx. 27 min.
Courtesy of the artist

Untitled (Malcom X)
c. 1986
Graphite on vellum
7 × 5 in.
Collection of Kay Sardo

Untitled (Marcus Garvey)
c. 1986
Graphite on Paper
11 × 8½ in.
Collection of Kay Sardo

Untitled (Miss America study)
c. 1989
Graphite and oil on vellum
18 × 11½ in.
Courtesy of the artist

Untitled (preparatory sketch)
c. 1989
Graphite on vellum
14 × 19 in.
Courtesy of the artist

Untitled (preparatory sketch)
c. 1989
Oil and mixed media on board
14 × 17 in.
Courtesy of the artist

Untitled (preparatory sketch)
c. 1989
Oil and mixed media on board
20 × 24 in.
Courtesy of the artist

Untitled (Miss America study)
c. 1989
Graphite on vellum
16½ × 17 in.
Courtesy of the artist

Untitled (Miss America study)
c. 1989–1992
Graphite on vellum
24 × 24 in.
Courtesy of the artist

* Untitled (Miss America)
c. 1989–1992
Silver gelatin print
10 × 8 in.
Courtesy of the artist

*Untitled (Ed Bereal and Nasa Scientist Chris Chyba in Siberia)
1991
Photo: Courtesy of the artist

Gargoyles
1992
Graphite on paper
21 × 16½ in.
Courtesy of the artist
Photo: Courtesy of Harmony Murphy Gallery, Los Angeles

Miss America
1993
Oil on paper
24 × 20½ in.
Courtesy of the artist
Photo: Courtesy of Harmony Murphy Gallery, Los Angeles

Homage to LA: Just a Lil' Sumpthin for the Kids
1994
Mixed media and found object
84 × 63 × 32 in.
Courtesy of the artist
Photo: Courtesy of Harmony Murphy Gallery, Los Angeles

Untitled (study for *Who's the Boogie Man*)
c. 1998
Oil and mixed media on board
24½ × 17½ in.
Courtesy of the artist

*Untitled (life drawing class, Western Washington University)
c. 1998
Silver gelatin print
5 × 5 in.
Courtesy of the artist

Salah M. Abdul-Wahid
Untitled (documentary photograph, Kosovo)
1998–1999
C-print
8 × 10 in.
Courtesy of Salah M. Abdul-Wahid and Ed Bereal

Salah M. Abdul-Wahid
Untitled (documentary photograph, Kosovo)
1998–1999
C-print
8 × 10 in.
Courtesy of Salah M. Abdul-Wahid and Ed Bereal

Salah M. Abdul-Wahid
Untitled (documentary photograph, Kosovo)
1998–1999
C-print
8 × 10 in.
Courtesy of Salah M. Abdul-Wahid and Ed Bereal

Untitled (preparatory sketch)
c. 1999
Graphite on vellum
22½ × 14¾ in.
Courtesy of the artist

The Birthing of the American Middle Class
1999
Oil on composite material
80 × 50 in.
Courtesy of the artist
Photo: Courtesy of David Scherrer

Untitled (preparatory sketches for *The Birthing of the Middle Class*)
c. 1999–2000
Graphite and mixed media on vellum
70 × 40 in.
Courtesy of the artist

Untitled (preparatory sketch)
c. 1999–2003
Graphite and paint on paper
48 × 32 in.
Courtesy of the artist

Untitled (preparatory sketch)
c. 2000
Graphite and mixed media on vellum
70 × 40 in.
Courtesy of the artist

Untitled (preparatory sketch)
c. 2000
Graphite and mixed media on vellum and board
70 × 40 in.
Courtesy of the artist

In Gods We Trust
2000
Graphite and mixed media on paper
37¼ × 24 in.
Courtesy of the artist

Miss America: Manufacturing Consent: Upside Down and Backwards
2000–2015
Mixed media and found object
10 × 12½ × 16 ft.
Courtesy of the artist
Photo: Courtesy of Harmony Murphy Gallery, Los Angeles

Wild Bill and Miss A. (Made in the U.S.A.)
2001
Graphite on paper
18½ × 23½ in.
Courtesy of the artist
Photo: Courtesy of Harmony Murphy Gallery, Los Angeles

Untitled (study for *Again*)
2002
Graphite and mixed media on vellum
40 × 54 in.
Collection of Ken Hanna

Again (Miss America, George Dubya and the Missing Florida Votes)
2002
Oil on composite material
38½ × 49¾ in.
Courtesy of the artist
Photo: Courtesy of Harmony Murphy Gallery, Los Angeles

El Producto, a Plumber's Friend
2002
Graphite and mixed media on paper
27 × 40 in.
Collection of Kay Sardo

Miss America Preparing John Doe for Public Service
c. 2002–2003
Oil on composite material
96 × 50 in.
Courtesy of the artist

America's Self Portrait; Three Schmucks & We're Out
2003
Oil on composite material
34¾ × 23 in.
Courtesy of the artist
Photo: Courtesy of Harmony Murphy Gallery, Los Angeles

Hollywood Apartheid
2003
Graphite on paper
37¼ × 24 in.
Collection of Warren and Billie
Blakeley

*Military/Business + God = War +
Kids*
2003
Graphite on paper
36⅜ × 24½ in.
Collection of Casey Kaufman
Photo: Courtesy of Harmony Murphy
Gallery, Los Angeles

Social Security
 2003
Graphite on paper
37¼ × 24 in.
Collection of Jane and Robert
Sylvester

*Miss America Presents Domestic
Terrorism*
2003/2015
Graphite on paper
48 × 45 in.
Courtesy of the artist
Photo: Courtesy of Harmony Murphy
Gallery, Los Angeles

Sketch for *Mona Lisa/Condoleezza,
Angel of Darkness*
2004
Graphite on paper
36⅜ × 24 in.
Collection of Allan and Luwana Bereal

*Mona Lisa/Condoleezza, Angel of
Darkness*
2004
Oil on composite material
41¼ × 29 in.
Courtesy of the artist
Photo: Courtesy of Harmony Murphy
Gallery, Los Angeles

Self Portrait; Still Lost In the USA
2004
Graphite and mixed media on paper
17 × 13 in.
Courtesy of the artist
Photo: Courtesy of Harmony Murphy
Gallery, Los Angeles

Kid with Gun
2006
Graphite and mixed media on paper
24 × 14 in.
Collection of Jane and Robert
Sylvester

*Location, Location, Location (Iraq/
Afghanistan)*
2006
Oil on composite material
73 × 42½ in.
Courtesy of the artist
Photo: Courtesy of Harmony Murphy
Gallery, Los Angeles

Untitled (Self Portrait with Condi)
2009
Graphite and mixed media on paper
11 × 8½ in.
Collection of Kay Sardo

Joker
2011
Mixed media and found objects
49 × 64 × 16 in.
Courtesy of the artist
Photo: Courtesy of Harmony Murphy
Gallery, Los Angeles

Untitled (Ariel Sharon)
c. 2011
Graphite on paper
13¾ × 10¾ in.
Courtesy of the artist
Photo: Courtesy of Harmony Murphy
Gallery, Los Angeles

Five Horsemen of the Apocalypse
2011–2019
Mixed media and found objects
8 × 40 × 3½ ft.
Courtesy of the artist
Photo: Courtesy of David Scherrer

* Untitled (Bodacious Buggerrilla
 reunion performance of *Killer Joe*)
2012
C-Print
11 × 14 in.
Courtesy of the artist

Untitled (preparatory sketch)
c. 2018
Graphite on paper
14 × 11 in.
Courtesy of the artist

Make America White Again
2018–2019
Mixed media
60 × 40 in.
Courtesy of the artist

* Untitled (Ed Bereal in his studio,
 Bellingham, Washington)
2019
Digital Image
Courtesy of the artist
Photo: Courtesy of
David Scherrer

Untitled (Compilation video
documenting *America: A Mercy Killing*,
Bodacious Buggerrilla performances,
and *Pull Your Coat*)
2019
Video with sound
11 × 14 in.
Courtesy of the artist, David Scherrer,
and Steve Johnson

Untitled (Miss America study)
c. 1989
Graphite and oil on vellum
18 × 11½ in.
Courtesy of the artist

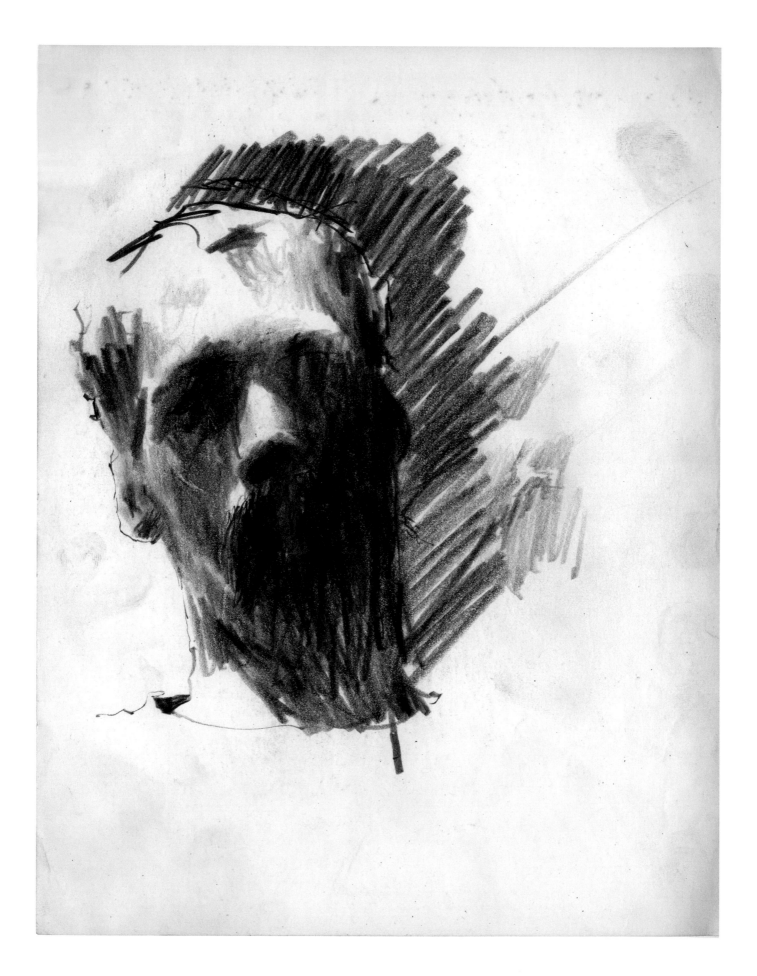

Alcoff, Linda Martín. *Visible Identities: Race, Gender, and the Self*. Oxford: Oxford University Press, 2006.

Bereal, Ed. "In Search of Ms. America: An Autobiography of the Watts Years, 1965–1975." Special issue on art and politics in Los Angeles, edited by George Herms, *New Observations* 92 (November–December 1992): 18–19.

Bereal, Ed. "I Never Gave Up." Unpublished open letter to Monte Factor, 2005. Collection of Ed Bereal.

Bereal, Ed. Interview by Amy Chaloupka and Matthew Simms, transcribed by Matthew Simms. Bellingham, WA (March 10, 2019).

Bereal, Ed. Interview by Virginia Mecklenburg and others, transcribed by Diana Van Wagner and H. Ingalls, edited by Ed Bereal. Archives of American Art, Smithsonian Institution, Washington, DC (April 20, 2010).

Bereal, Ed. "Oral History Interview with Ed Bereal." Interview by Hunter Drohojowska-Philp. Archives of American Art, Smithsonian Institution, Washington, DC (February 13, 2016).

Childress, Sarah. "The Problem with Broken Windows Policing." *Frontline*, Public Broadcasting Service (June 28, 2016). https://www.pbs.org/wgbh/frontline/article/the-problem-with-broken-windows-policing/.

Cohen, Jerry. "Coroner's Jury to Sift Facts in Police Slaying of Negro." *Los Angeles Times*. May 18, 1966.

Coplans, John. "Sculpture in California." *Artforum* 2, no. 2 (August 1963): 4.

Factor, Donald. "Assemblage." *Artforum* 2, no. 12 (Summer 1964): 38.

Grenier, Catherine. *Los Angeles 1955–1985*. Paris: Centre Pompidou, 2006.

Hadeishi, Nobuyuki. "The Last Years (1956–1972)." In *Chouinard: A Living Legacy*, (40–63). Los Angeles: Chouinard Foundation, 2001.

Headley, Cleavis. "Delegitimizing the Normativity of 'Whiteness': A Critical Africana Philosophical Study of the Metaphoricity of 'Whiteness.'" In *What White Looks Like: African American Philosophers on the Whiteness Question*, edited by George Yancy, 95. New York: Routledge, 2004.

Hill, Gladwin. "Widow Testifies on Watts Killing." *New York Times,* May 25, 1966.

Hopkins, Henry Tyler. "Oral History Interview with Henry Tyler Hopkins." Interview by Wesley Chamberlin. Archives of American Art, Smithsonian Institution, Washington, DC (Oct. 24 and Dec. 17, 1980).

Jones, Kellie, ed. *Now Dig This!: Art and Black Los Angeles, 1960–1980*. Hammer Museum, Los Angeles: DelMonico Books/Prestel.

Kienholz, Lyn, with Elizabeta Betinski and Corinne Nelson, eds. *L.A. Rising: SoCal Artists Before 1980*. Los Angeles: California/International Arts Foundation, 2010.

King, Martin Luther. "A Time to Break the Silence." (Speech delivered at Riverside Church, New York, April 4, 1967.) In *I Have a Dream: Writings and Speeches that Changed the World*, edited by James M. Washington, 135–52. San Francisco: Harper Collins, 1992.

Kook-Anderson, Grace. *Best Kept Secret: UCI and the Development of Contemporary Art in Southern California, 1964–1971*. Laguna Beach, CA: Laguna Art Museum, 2011.

Loomis, Andrew. *Successful Drawing*. New York: Viking Press, 1951.

Lord, Benjamin. "Ed Bereal Speaks." *Contemporary Art Review Los Angeles* (July 7, 2016). https://contemporaryartreview.la/ed-bereal-speaks/.

Lyons, Sandra. "Interview with Ed Bereal." *Wordworks, Inc.* IV, no. 1 (March 1981): 19–22.

Nittve, Lars, and Lena Essling, eds. *Time & Place: Los Angeles 1957–1968*. Stockholm: Steidl, 2008.

Patterson, John. "California Dreamers: The Story of Art in the 1950s and '60s." *The Guardian*, October 7, 2009. https://www.theguardian.com/artanddesign/2009/oct/08/california-1960s-art.

Schulberg, Bud, ed. *From the Ashes: Voices of Watts*. New York: Meridian Books, 1967.

Umberger, Leslie. "In Memory of the Blood." In *Something to Take My Place: The Art of Lonnie Holley*, 20. Charleston, SC: Halsey Institute of Contemporary Art, 2015.

Valéry, Paul. Cited by Maurice Merleau-Ponty. "Eye and Mind." In *The Merleau-Ponty Aesthetics Reader: Philosophy and Painting*, edited by Galen A. Johnson, translated by Michael B. Smith, 123. Evanston, IL: Northwestern University Press, 1993.

Weisenberg, Charles M. "Black Talent Speaks." *Los Angeles FM & Fine Arts* 8, no.1. (January 1967): 4–11.

Widener, Daniel. *Black Arts West: Culture and Struggle in Postwar Los Angeles*. Durham, NC: Duke University Press, 2010.

Weisman, John. *Guerrilla Theater: Scenarios for Revolution*. New York: Anchor Press, 1973.

Tilton, Connie Rogers, and Lindsay Charlwood, eds. *L.A. Object & David Hammons Body Prints*. New York: Tilton Gallery, 2011.

Peabody, Rebecca, Andrew Perchuk, Glenn Phillips, and Rani Singh, eds. *Pacific Standard Time: Los Angeles Art 1945–1980*. Los Angeles: Getty Research Institute and J. Paul Getty Museum, 2011.

Untitled (self-portrait)
c. 1958–1965
Graphite on paper
11 × 8½ in.
Courtesy of the artist

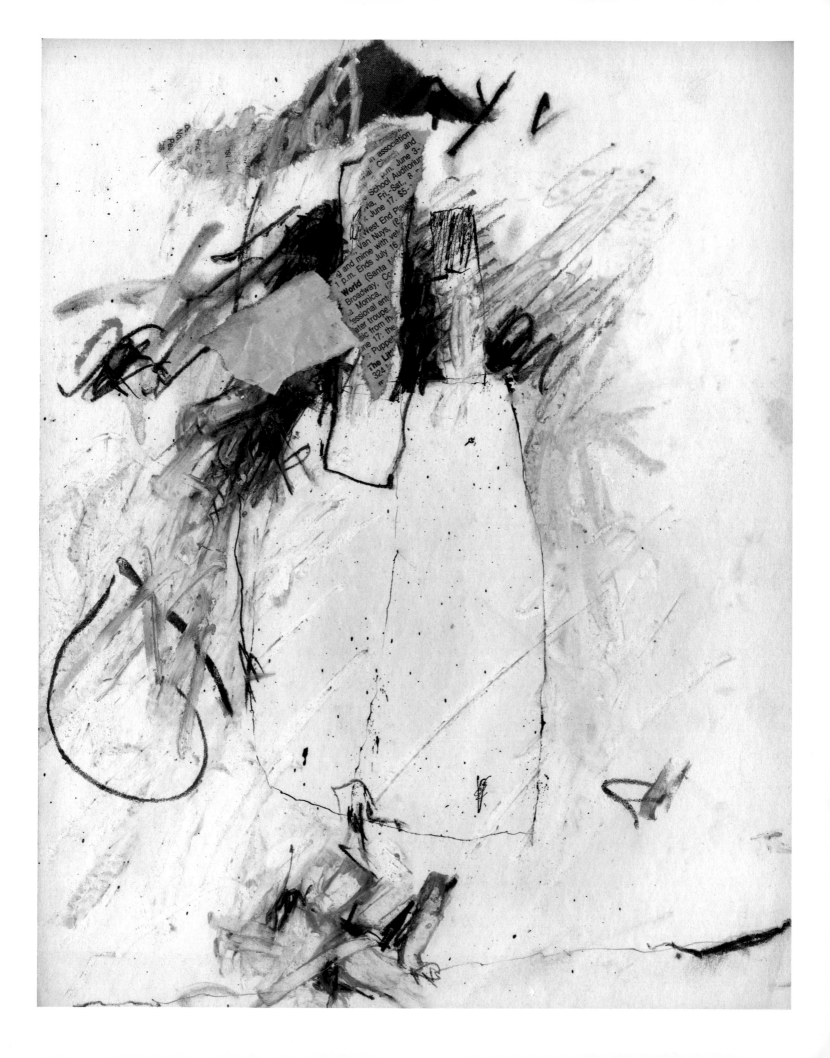

CONTRIBUTORS

Amy Chaloupka is curator of art at the Whatcom Museum and has organized more than twenty exhibitions over the last twelve years. Chaloupka has written numerous essays for exhibition publications and has led major exhibition initiatives, including *Colorfast: Vivid Installations Make their Mark* (Whatcom Museum, 2016), *Crossover: Cruce de Vias* (The Western Gallery, Western Washington University, 2015), *Nek Chand: The World In A Garden,* and *Hiding Places: Memory in the Arts* (John Michael Kohler Arts Center, Sheboygan, Wisconsin, 2017 and 2010).

Malik Gaines is a writer and artist, a member of the performance group My Barbarian, and assistant professor of performance studies at New York University's Tisch School of the Arts. Gaines holds a PhD in theater and performance studies from UCLA, having researched the transnational politics of race and gender in performances of the 1960s. He is the author of *Black Performance on the Outskirts of the Left: A History of the Impossible* (New York: NYU Press, 2017). Gaines has contributed to numerous art publications and catalogues, including monographs for Mark Bradford, Andrea Bowers, Sharon Hayes, Glenn Ligon, and Wangechi Mutu.

Vernon Damani Johnson has been a faculty member in the Department of Political Science at Western Washington University since 1986. His research interests include comparative settler colonialism, African politics, and American race and public policy. He currently serves as the program director for the Munro Institute for Civic Education. Johnson served on both the advisory committee to Jesse Jackson's 1988 presidential campaign and the Steering Committee of the Washington State Rainbow Coalition from 1988 to 1992. Johnson has conducted numerous public presentations on race and law enforcement in the post-Ferguson era and authored *The Structural Origins of Revolution in Africa*, (Lewiston, New York: Edwin Mellen Press, 2003).

Matthew Simms is professor of art history at California State University, Long Beach and Gerald and Bente Buck West Coast Collector for the Archives of American Art, Smithsonian Institution. He is the author of books on Paul Cézanne and Robert Irwin and recently curated the exhibition *Robert Irwin: Site Determined*. He is currently developing a monograph on the work of Light and Space artist Helen Pashgian.

Untitled
1968
Mixed media on paper
16 × 12 in.
Courtesy of the artist

This publication accompanies the exhibition *Wanted: Ed Bereal for Disturbing the Peace*, organized by Amy Chaloupka for the Whatcom Museum, September 7, 2019–January 5, 2020.

Major funding for the exhibition and catalogue has been provided by Larry Bell, the City of Bellingham, RiverStyx Foundation, Michael & Barbara Ryan, and the Whatcom Museum Foundation, with additional support from Sharron Antholt, Antonella Antonini & Alan Stein, Patricia Burman, Heritage Bank, Galie Jean-Louis & Vincent Matteucci, Janet & Walter Miller Fund for Philanthropic Giving, Ann Morris, Peoples Bank, Charles & Phyllis Self, Mary Summerfield & Mike O'Neal, Jane Talbot & Kevin Williamson, Nancy Thomson & Bob Goldman, the Whatcom Community Foundation, and the Whatcom Museum Advocates.

WHATCOM MUSEUM

Published in the United States by
The Whatcom Museum
121 Prospect Street
Bellingham, Washington 98225
www.whatcommuseum.org

First edition, 2019

Designed by Phil Kovacevich
Edited by Nancy S. Tupper

Printed in Canada by Friesens Book Division

Distributed by the University of Washington Press
Box 359570
Seattle, WA 98195-9570
www.washington.edu/uwpress

ISBN: 978-0-578-48693-2
Library of Congress Control Number: 2019909993

The paper used in this publication has been certified by the Forest Stewardship Council.

Cover:
Self Portrait; Still Lost In the USA, detail
2004
Graphite and mixed media on paper
17 × 13 in.
Courtesy of the artist
Photo: Courtesy of Harmony Murphy Gallery, Los Angeles

Page 1:
Untitled (*Disturbing the Peace* Exhibition poster)
2002
Ink on paper
22 × 17 in.
Courtesy of the artist

Frontispiece:
Homage to LA: Just a Lil' Sumpthin for the Kids, detail
1994
Mixed media and found object
84 × 63 × 32 in.
Courtesy of the artist
Photo: Courtesy of Harmony Murphy Gallery, Los Angeles

Page 4:
Untitled
1963
Mixed media and found object
10¾ × 8⅜ in.
Courtesy of the artist
Photo: Courtesy of Harmony Murphy Gallery, Los Angeles

Back cover:
Focke-Wulf FW 190, detail
1960
Mixed media
21¼ × 12 × 6 in.
The Buck Collection at the UCI Institute and Museum for California Art
© 2018 The Regents of The University of California